THE COIN COLLECTING BIBLE

The Ultimate No-Nonsense Guide to Mastering Coin Collecting—From Identifying Valuable Pieces to Maximizing Your Investment and Avoiding Costly Mistakes

Hugh Greenwood

© **Copyright 2024 by Hugh Greenwood - All rights reserved.**

The following book is provided below with the aim of delivering information that is as precise and dependable as possible. However, purchasing this book implies an acknowledgment that both the publisher and the author are not experts in the discussed topics, and any recommendations or suggestions contained herein are solely for entertainment purposes. It is advised that professionals be consulted as needed before acting on any endorsed actions.

This statement is considered fair and valid by both the American Bar Association and the Committee of Publishers Association, and it holds legal binding throughout the United States.

Moreover, any transmission, duplication, or reproduction of this work, including specific information, will be deemed an illegal act, regardless of whether it is done electronically or in print. This includes creating secondary or tertiary copies of the work or recorded copies, which are only allowed with the express written consent from the Publisher. All additional rights are reserved.

The information in the following pages is generally considered to be a truthful and accurate account of facts. As such, any negligence, use, or misuse of the information by the reader will result in actions falling solely under their responsibility. There are no scenarios in which the publisher or the original author can be held liable for any difficulties or damages that may occur after undertaking the information described herein.

Additionally, the information in the following pages is intended solely for informational purposes and should be considered as such. As fitting its nature, it is presented without assurance regarding its prolonged validity or interim quality. Mention of trademarks is done without written consent and should not be construed as an endorsement from the trademark holder.

TABLE OF CONTENTS

INTRODUCTION ... 9

1. Welcome to the Fascinating World of Coin Collecting .. 9
The Joys and Challenges of Numismatics ... 9
How to Use This Book .. 10

PART I: FOUNDATIONS OF COIN COLLECTING ... 11

2. The History of Coinage ... 11
Ancient Origins .. 11
Evolution Through the Centuries .. 13
Modern Coinage Systems .. 15

3. Getting Started with Coin Collecting ... 17
Why Collect Coins? ... 17
Essential Terminology .. 19
Types of Coin Collections .. 20

PART II: IDENTIFYING AND UNDERSTANDING COINS .. 23

4. Identifying Coins ... 23
Reading Coin Details: Dates, Mintmarks, and Inscriptions ... 23
Identifying Coin Types and Varieties .. 25
Tools for Identifying Coins .. 26

5. Grading Coins ... 29
Understanding Coin Grades .. 29
The Grading Scale: From Poor to Mint State .. 30
Third-Party Grading Services ... 31

PART III: BUILDING YOUR COLLECTION ... 33

6. Starting Your Collection ... 33
Picking Your Focus: Types, Themes, and Eras ... 33
Setting a Budget .. 34
Finding Your First Coins .. 36

7. Expanding Your Collection .. 39
Advanced Collecting Strategies ... 39
Building a Thematic Collection ... 41
Networking with Other Collectors ... 42

8. Buying Coins .. 45
Where to Buy: Auctions, Dealers, Shows, and Online 45
Spotting a Good Deal .. 47
Avoiding Counterfeits and Scams ... 48

PART IV: MANAGING AND PROTECTING YOUR COLLECTION 51

9. Coin Storage and Display ... 51
Best Practices for Coin Storage .. 51
Displaying Your Collection ... 53
Safeguarding Against Loss and Damage ... 54

10. Coin Preservation and Cleaning ... 57
When and How to Clean Coins .. 57
Professional Preservation Techniques .. 58
Common Mistakes to Avoid .. 60

11. Documenting Your Collection ... 63
Cataloging and Record Keeping .. 63
Software and Tools for Coin Documentation 64
Assessing Your Collection's Value .. 66

12. The Coin Market ... 69
Understanding Coin Valuation .. 69
Market Trends and Influences .. 71
Investing in Coins .. 72

13. Rare Coins and Hidden Gems ... 75
Identifying Rare Coins ... 75
The Most Valuable Coins in History ... 77
How to Spot Hidden Gems .. 78

14. Selling Coins .. 81
Preparing Coins for Sale .. 81
Choosing the Right Selling Platform .. 82
Negotiating and Closing Sales .. 84

PART VI: THE COLLECTOR'S COMMUNITY 87

15. Joining the Numismatic Community .. 87
Local and National Coin Clubs ... 87
Benefits of Membership .. 88

 Participating in Coin Shows and Conferences ... *90*

16. RESOURCES FOR COLLECTORS ...93
 Essential Books and Magazines ..*93*
 Online Forums and Websites ..*94*
 Coin Collecting Apps..*96*

17. TIPS FOR LIFELONG COLLECTING ..99
 Continuing Education for Collectors ..*99*
 Staying Passionate and Informed ...*100*
 Future Trends in Coin Collecting ...*102*

INTRODUCTION

1. WELCOME TO THE FASCINATING WORLD OF COIN COLLECTING

THE JOYS AND CHALLENGES OF NUMISMATICS

The allure of numismatics can be attributed to several factors, each contributing an essential strand to the rich tapestry of this hobby. One of the principal joys lies in the profound connection with history. Each coin is a piece of the past—a tangible link to an era, ruler, or event that shaped the course of human history. Collectors often find themselves on a thrilling journey through time, from the ancient markets of Lydia, where coinage is thought to have originated, to modern mints producing high-tech, limited edition pieces.

Furthermore, the satisfaction derived from discovering and acquiring rare or significant coins is immense. Imagine the exhilaration of identifying a coin that has eluded collectors for decades or finding a piece that completes a thematic collection, be it coins from every nation or specific historical periods. Such achievements are celebrated milestones in every numismatist's life.

Aesthetic appreciation also plays a critical role. Coins are miniature artworks that exhibit craftsmanship, artistic skills, and periods of aesthetic trends. Collectors often develop a keen eye for design nuances, enjoying the beauty of engravings and relishing the stories these images tell.

Then there's the intellectual stimulation associated with research and study in coin collecting. The hobby encourages continuing education, where one learns not only about numismatics but also about economics, politics, and technology. It's a pursuit that sharpens the mind, offering endless opportunities for learning and personal growth.

Community engagement further enriches the coin collecting experience. Whether through local clubs, online forums, or national shows, collectors connect with like-minded enthusiasts. These communities foster friendships, facilitate exchanges of knowledge, and provide a network of support that helps collectors to refine their hobby.

The Challenges of Coin Collecting

Despite these joys, coin collecting does not come without its challenges. Each obstacle, however, also presents an opportunity for growth and learning, making overcoming them all the more rewarding.

One primary challenge in numismatics is the acquisition of expertise required to successfully identify, appraise, and care for coins. The market is vast, and with it comes the task of understanding the intricate details that determine a coin's value. Issues like historical significance, rarity, condition, and demand must be studied and understood. New collectors often face a steep learning curve as they start to navigate these waters.

Counterfeits and overvalued coins present a significant risk. The market has its share of pitfalls, with unscrupulous sellers who may prey on inexperienced collectors. Learning to distinguish authentic coins from forgeries requires experience, a trained eye, and often, reliance on professional grading services. Making informed purchases, thus, demands vigilance and an ongoing engagement with the numismatic community and trusted experts.

Moreover, maintaining and organizing a collection poses its own set of challenges. Proper storage is crucial for preserving the condition of coins, as environmental factors like humidity, temperature, and light can cause deterioration. Additionally, cataloging a growing collection demands diligence and can become overwhelming. Utilizing the right tools and adopting systematic approaches are essential for managing this aspect effectively.

Budgeting is another significant challenge. Coin collecting can be an expensive hobby, particularly when pursuing rare items or building large collections. Financial management thus becomes crucial as collectors need to balance their passion with their spending, ensuring that their hobby does not financially overburden them.

Finally, the challenge of time management cannot be understated. Balancing coin collecting with other life responsibilities requires thoughtful planning and dedication. For many, finding time to attend auctions, visit dealers, research coins, and participate in community events can be daunting.

How to Use This Book

Navigating the intricacies of any new hobby can be as daunting as it is exciting, and coin collecting is no exception. Understanding how to use this book will empower you to embark upon your numismatic journey with both confidence and enthusiasm. Consider this guide as your companion in discovering the wealth of stories each coin in your collection holds, from ancient artifacts to contemporary treasures.

Visualize yourself stepping into a vast library, each book and scroll offering insights into different epochs of history, each artifact tucked on its shelves a story of its own. **The Coin Collecting Bible** aims to be just that—a comprehensive volume packed with knowledge, not only to educate you about coins but also to enhance your enjoyment and proficiency in collecting them.

Our journey through the book is designed to progressively build your knowledge and skills in numismatics. It begins with foundational information and gradually delves into more complex aspects of coin collecting. Here's how each part is structured to guide you from the basics to advanced levels:

PART I: FOUNDATIONS OF COIN COLLECTING
2. THE HISTORY OF COINAGE

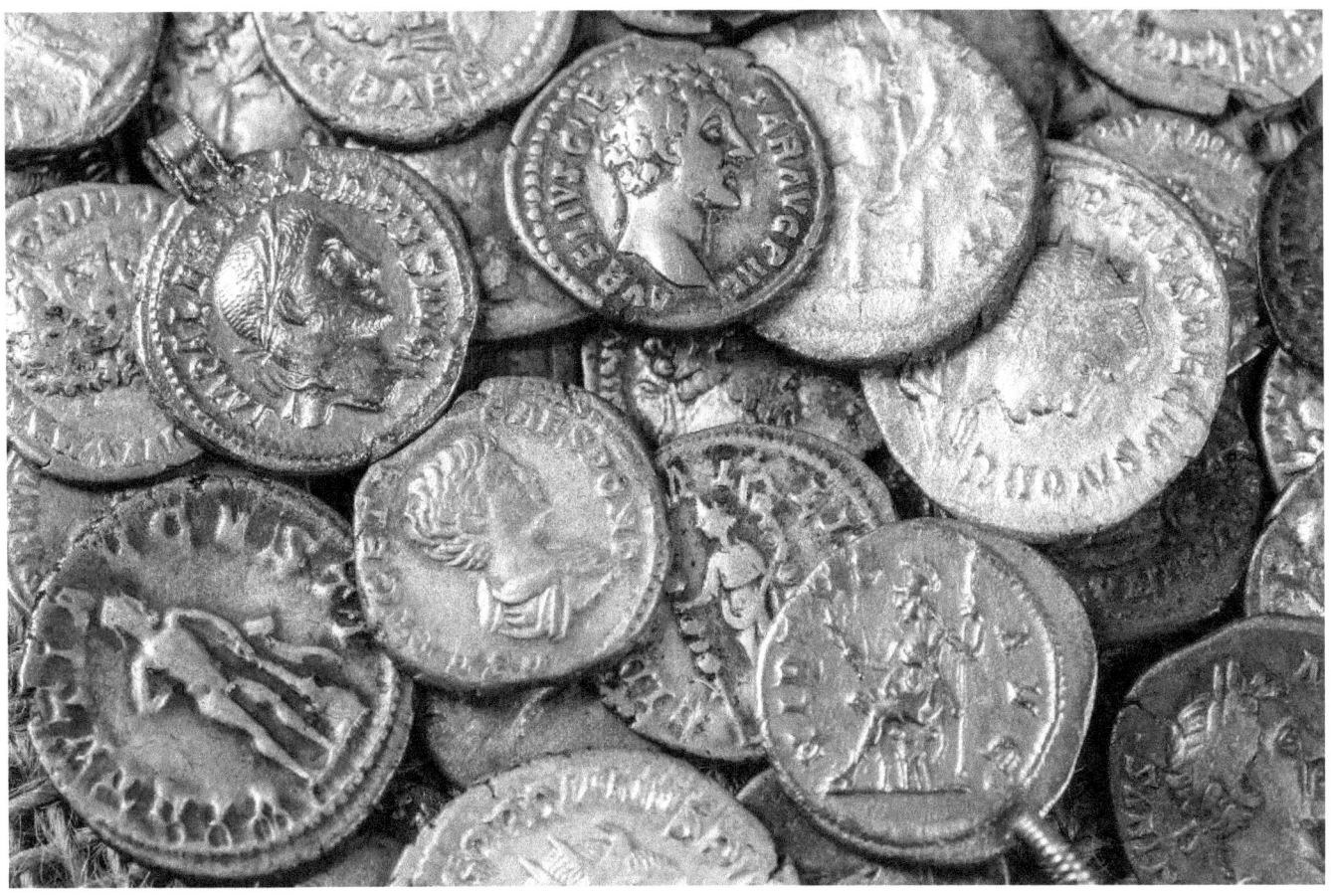

ANCIENT ORIGINS

Coins are not merely pieces of metal but repositories of history, culture, and the artistry of civilizations long gone. The story of how coinage began is a fascinating journey into the ancient world, a reflection of humanity's genius and its relentless pursuit for organization and commerce. The inception of coinage can be traced back to the ancient realms of Lydia, a kingdom in what is now modern Turkey, around the 7th century BCE. Before coins were introduced, trade was predominantly a barter system—a direct exchange of goods and services, which had obvious limitations. Imagine trying to determine how many bushels of wheat were equivalent to a cow or how many pots of wine could be traded for cloth. The inherent inefficiency in these trades led to the need for a standardized medium of exchange, a need that gave birth to coinage.

Lydia's natural resources played a pivotal role in its pioneering of coin-making. With rivers rich in electrum, an alloy of gold and silver, Lydians found themselves with the ideal material for creating coins. These early coins were stamped with distinguishing marks, signifying authenticity and weight—a primitive yet effective quality assurance system to foster trust among traders. Interestingly, the history of coins is also deeply intertwined with the desire of rulers to showcase

power and authority. The images stamped on these ancient coins weren't merely for decoration but served as a projection of the sovereign's image, much like modern national symbols on today's currency. A coin bearing the likeness of a ruler was a constant reminder of who held the power, an early form of political propaganda, if you will.

As trade networks expanded across the Mediterranean and beyond, the concept of coinage spread to other cultures and civilizations. The Greeks, renowned for their contributions to art and philosophy, also excelled in the refinement of coin production. They introduced coins that featured intricate designs and high relief, transforming these pieces from mere trade objects into works of art. One could argue that each coin was a miniature billboard for a city-state's culture and ideals—a form of branding that conveyed messages about the power and prestige of its people.

In ancient Greece, different city-states issued their own currency, often depicting their chosen symbols, like the owl for Athens and the dolphin for Corinth. These symbols were more than decor; they communicated the identity and sovereignty of the city, bolstering a sense of pride among its citizens and a recognition of mutual economic values among other states.

The spread of coinage was similarly revolutionary in the Roman Empire, which took the concept and turned it into a colossal system of currency that supported trade and military expansion across three continents. Roman coinage further revolutionized the way that currency could be used to stabilize a society, finance wars, and build infrastructure. Each coin bore the Emperor's image, which not only served as a tool for political control but also as a means of spreading the imperial cult. This ubiquity of coins, bearing witness to Rome's expansive power, meant that a farmer in distant Britannia could be holding the same currency as a merchant in sun-baked Egypt.

Beyond the political and social implications, ancient coinage also had profound economic impacts. For the first time, the value of an item could be gauged with relative precision, a concept that laid the groundwork for modern economic theories and practices. Such standardization enabled traders and merchants to accumulate wealth and savings, accelerating the development of a middle class—a segment of society that could influence power through wealth rather than birthright or military might.

Moreover, coins facilitated the collection of state revenues more effectively than the previous cumbersome methods. Taxes could now be standardized, collected, and stored with greater ease, leading to better-maintained cities and a more efficiently administered state. The evolution of coinage brought with it the development of sophisticated financial instruments—credit, loans, and even early forms of banks that began to appear in temple complexes where large amounts of coins could be securely stored. Amid these advancements, the artistry of coin-making flourished, with each culture bestowing its unique touch.

From the Hellenistic kingdoms featuring rulers in divine forms to the intricate Islamic coinage that abstained from human figures in favor of beautiful calligraphy, coinage mirrored the evolution of human societies.

As we journey through the narrative of ancient origins in coinage, it becomes clear that these metal pieces were much more than facilitators of commerce. They were bearers of culture, indicators of technological advancement, instruments of political control, and catalysts in the creation of societal structures. The development of coinage marked a significant leap in human civilization, paving the way for economic systems that would one day circle the globe.

While this brief exploration barely scratches the surface of ancient coinage, understanding its origins enriches our appreciation of coins not just as collectibles but as pivotal chapters in the grand narrative of human history. As collectors, every coin we hold isn't just a piece of metal—it's a fragment of the past, calling out to be preserved and understood.

EVOLUTION THROUGH THE CENTURIES

As the wheel of time turned from the ancient to the medieval period, the evolution of coinage mirrored the profound transformations of societies, wars, and ideologies. This evolution, both in form and function, speaks volumes about the periods it transcended and the human narratives intertwined with these bits of metal.

Following the intricate coins of ancient cultures, the fall of the Roman Empire plunged much of Europe into a turbulent period that affected all aspects of life, including the economy and the systems of coinage that had supported it. The Byzantine Empire, continuing the traditions of the eastern part of the Roman Empire, kept alive the legacy of coinage. Their solidus and later the hyperpyron were widely recognized in trade, testimony to the Empire's economic resilience and a bridge to the coinage practices of modern Europe.

As Europe staggered through the early Middle Ages, the diversity in coinage saw a dramatic rise. With feudalism at its peak, numerous feudal lords minted their own money as a symbol of autonomy. These coins were often of poor quality and limited circulation, mirroring the fragmented political landscape of the time. The medieval period thus witnessed not just a proliferation of coin types but also significant variability in weight and size. This variability was not merely a product of technological limitations or lack of resources, but a reflection of the prevailing socio-political isolation.

The scene was markedly different in the Islamic world, where the spread of Islam in the 7th century introduced a new era in coinage. Islamic caliphates created a unified currency system that enhanced trade across a vast territory stretching from Spain in the West to the Indus in the East.

The designs of Islamic coins abstained from human and animal representations, adhering to religious tenets, and instead featured intricate calligraphic designs. This period underscored how coinage systems could unify diverse cultures under a single economic and cultural ethos.

As we move into the late medieval age, a significant revolution in European coinage occurred. The proliferation of trade and the growth of city-states in places like Italy and the Low Countries necessitated larger denominations that could facilitate more substantial transactions. This need gave birth to 'Groschen' and 'Ducats', larger coins that carried more value and boasted better metal quality. These coins helped lubricate the wheels of commerce not only domestically but in international trade, becoming precursors to the modern currencies.

The Renaissance brought about a reinvigorated interest in the art and science of coin-making, largely influenced by the humanist revival of the Greco-Roman heritage. Coins became not only tools of trade but also objects of art, showcasing exquisite designs and the rulers' visages crafted with unprecedented detail. This era also observed the emergence of sophisticated minting techniques, including the introduction of the screw press which revolutionized coin production by making it faster and giving coins a more uniform shape and size.

The pivotal moment in the history of coinage, however, came with the Age of Discovery, which expanded the geographical and cultural horizons of European powers. The vast influx of precious metals from the New World into Europe could have potentially wreaked havoc on the value systems of European currencies. However, it instead facilitated the expansion of European economies outward, intensifying the need for a more standardized, reliable monetary system. This period demonstrated how the forces of exploration and colonization were reflected in the metals and mints of European coinage.

Transitioning into the modern period, the industrial revolution ushered in new methods and scales of coin production. The adoption of steam-powered presses and later, electrically driven presses, led to mass production of coins, making them more accessible to the burgeoning middle classes. This period saw the birth of the modern monetary systems as countries began to adopt standardized national currencies, marking a shift from the previously prevalent diversity of coins to a more unified monetary policy suitable for industrialized nation-states.

The development of coinage through the centuries has been a profound indicator of technological, political, and economic shifts. From the small, irregularly cut pieces of silver in the early medieval period to the sophisticated currency systems of today, each coin is not just a piece of history but a testament to the ingenuity and adaptability of human societies.

As collectors and numismatists, our journey through the ages via these coins offers us a unique vantage point. It allows us to appreciate not just the intrinsic value of these coins, but also their

deeper significance as markers of our collective journey through time. It's this profound connection between past and present, economics, and culture, that continues to fuel the passion for this age-old hobby.

MODERN COINAGE SYSTEMS

As we journey through the corridors of numismatic history into the contemporary epoch, the confluence of technological innovation and economic transformation has continuously reshaped the landscape of coinage systems. The era of modern coinage systems, evolving from the industrial revolution onward, is characterized by technological interventions and the strategic needs of nations shaping their fiscal identities through currency.

The industrial revolution set the stage for profound expansions in coin production. By the 19th century, with the advent of steam-powered minting processes, the concept of coins underwent a standardized yet innovative evolution. Economies at a global scale started to stabilize currency systems, which demanded not only mass production but also consistent high quality and intricate designs that were difficult to counterfeit.

The first noteworthy evolution in modern coinage was the introduction of the standardized decimal system in currency by various countries. The British decimal day in 1971 stands as a watershed, converting the pounds, shillings, and pence system to a simpler, more intuitive pounds and pence system, making transactions straightforward and reducing the complexities of financial calculations. This change illustrated the growing need for simplicity and efficiency in transactional systems, reflecting broader economic and social trends towards globalization and enhanced accessibility.

Furthermore, the 20th century witnessed an unprecedented level of scrutiny in terms of the materials used for coins. With precious metals like silver and gold becoming economically unviable due to their fluctuating market values, most nations transitioned to using base metals like copper, nickel, and zinc, which were more economical. The U.S. Coinage Act of 1965 marked a significant turning point, systematically eliminating silver from the production of most coins in favor of cheaper, more abundant metals. This transition was not just an economic decision; it was also a reflection of the changing dynamics of global metal resources and their implications on national economies.

The evolution of coinage in modern times is also marked by increasing security features to combat counterfeiting—a persistent threat in the monetary world. Micro-lettering, bi-metallic coins, intricate milling, and embedded security features like holograms have become commonplace, entwining technology with fiscal instruments. For instance, the Euro coins introduced in the 21st

century encapsulate these technologies, promoting security and trust in currency across multiple nations within the Eurozone.

Alongside these technological marvels, the aesthetic and symbolic aspects of coin design have flourished in the modern age. Coins are not just monetary instruments but are also emblematic of a nation's identity, cultural heritage, and technological prowess. Commemorative coins, celebrating significant events, historic figures, and monumental achievements have gained popularity, becoming collectors' treasures and patriotic symbols. They serve as reminders of a nation's journey, its trials, triumphs, and aspirations.

The recent advancements in digital transactions and the rise of virtual currencies pose new questions about the role of physical coins in daily commerce. Countries like Sweden are steadily moving towards becoming cashless societies, with coins and banknotes becoming increasingly obsolete in daily transactions. This shift represents a broader trend in financial transactions, where convenience, security, and speed are paramount.

Despite these trends, the cessation of coin production is not imminent globally. Many developing nations still rely heavily on coins for daily transactions due to lower access to digital banking infrastructure and the informal nature of their economies. Here, coins continue to serve not only as a medium of exchange but also as a vital component of financial inclusion, enabling economic participation for the unbanked populations.

The story of modern coinage is one of adaptation and advancement, reflective of broader economic trends and technological innovations. While the future of physical coins in an increasingly digital world seems uncertain, their journey from ancient artifacts to sophisticated instruments of trade encapsulates the ingenuity and adaptability of human civilizations in shaping their economic destinies. For collectors, this era offers a rich tableau of coins that not only represent monetary value but also artistic and historical narratives waiting to be explored and appreciated, preserving the legacy of our shared global heritage in tangible forms that one can hold and cherish.

3. Getting Started with Coin Collecting

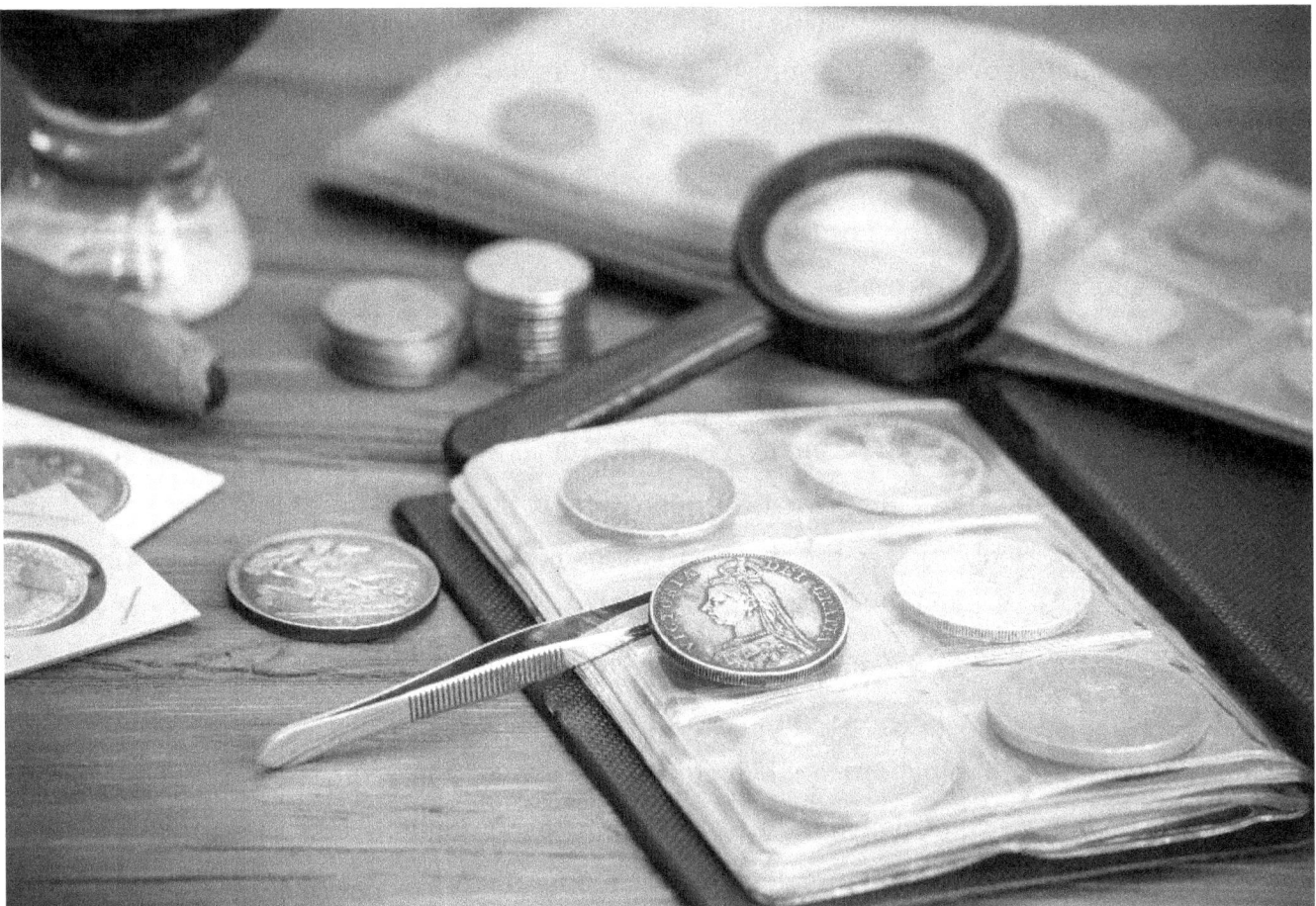

Why Collect Coins?

When one delves into the world of coin collecting, they often find themselves asking a fundamental question: "Why collect coins?" This inquiry touches the root of a hobby that spans generations and continents, a pursuit that combines artistic appreciation, historical curiosity, and financial insight. Imagine the thrill of holding a copper penny from the early 20th century—in your palm rests a piece of history, a token of an economy and culture long transformed. Coin collecting offers a tangible connection to the past. Each coin is a canvas, capturing the zeitgeist of its era. Through the emblems, monarchs, and inscriptions they bear, coins tell stories of political shifts, technological advancements, and social changes. Delving into the history each piece represents enriches one's understanding of human civilization. Beyond the historical allure, coin collecting appeals as a form of art appreciation. The craft of minting coins involves a blend of artistic design and precision engineering. Numismatists often marvel at the intricate details present in a coin: the careful etching of a national emblem, the delicate lines that form a leader's profile, and the thoughtful selection of symbols that convey a nation's identity. Collecting coins is akin to curating a gallery of miniature sculptures—a celebration of numismatic artistry that evolves with each minting technique refined and each era passed.

From a financial perspective, coin collecting can be a rewarding investment. Rare coins, especially those with historical significance or a minting flaw, often appreciate in value over time. Navigating the coin market to discover such treasures requires a blend of knowledge, patience, and strategic acumen, much like the broader art market. However, unlike other investments, coins allow for physical ownership, making them a uniquely tangible portfolio element. This aspect of coin collecting not only satisfies the need for aesthetic and historical appreciation but also caters to those looking for stable assets amid fluctuating markets.

The satisfaction of mastering a domain is another compelling answer to why people collect coins. The challenge lies in identifying, categorizing, and appraising coins—skills honed over time through study and participation. For many, coin collecting is an ongoing learning process enriched by each discovery and every numismatic interaction. It sharpens the eye to details that the untrained might overlook, such as the slight variations between coin issues or the significance of a mint mark. As collectors advance in their hobby, they often derive pride not just from the artifacts they accumulate but from the knowledge and expertise they have built.

Of course, the enjoyment and relaxation that coin collecting offers should not be underestimated. For many enthusiasts, flipping through their coin albums or visiting a coin show serves as a respite from the bustle and stress of daily life. It provides a focus, a meditative practice of sorts, where one can lose themselves in the minute details and broader histories of their collection. Hobbyists often speak of the zen found in examining their coins, whether organizing them, planning future acquisitions, or simply admiring their luster and lore.

Furthermore, coin collecting fosters a sense of community. Numismatists frequently gather at clubs, auctions, and conventions where they share passions, exchange knowledge, and often, forge lifelong friendships. In these spaces, hobbyists find others who share their interest in the stories and artistry held by each coin. This camaraderie enhances the collecting experience, offering outlets for sharing triumphs like a rare find or obtaining expert advice on a puzzling coin issue.

In engaging with the hobby, many collectors also find they contribute to the preservation of cultural heritage. By maintaining and expanding their collections, they keep alive the narratives and artistry of the past. Each coin curated and cared for is a preservation of history, safeguarded for future generations to study and appreciate.

ESSENTIAL TERMINOLOGY

Venturing into the realm of coin collecting is akin to exploring a new language, rich with its own vernacular and nuances. Every field has its jargon, and numismatics is no exception; mastering it is both fascinating and essential for anyone aspiring to become more than a casual collector. Grasping this terminology is not just about blending into the community; it's about deepening your understanding of the coins themselves and enhancing your ability to evaluate and appreciate your collection.

Consider the term "mint condition," often heard even outside the collecting world, typically signifying something new or untouched. In numismatics, this description carries more than mere casual meaning—it refers to a coin that is in its original state, as it was the moment it left the mint, without any wear and tear. This phrase encapsulates the ideal for many collectors: owning a piece that represents the pristine artistry and craftsmanship of the mint without the erosions of time and handling.

Moving further into our glossary, you might encounter "proof." While commonly associated with evidence or demonstration, in the world of coin collecting, a proof coin is one that has been struck with a special process that leads to more detailed and mirrored surfaces, usually intended for collectors rather than circulation. These are created with care, often double-struck to accentuate their design, embodying a level of detail that is both technical and aesthetic.

Another term frequently met is "numismatic." It might sound a bit scholarly, but it simply refers to anything pertaining to coins, currency, and medals. As a numismatic, you are part of a lineage that stretches back to the ancient collectors who appreciated coins not just for their utility, but for their artistry and history.

Let's dive into some terminology related to the physical aspects of coins, which can often be as cryptic as any ancient script until you learn to read them. "Obverse" and "reverse" refer, respectively, to the front and the back of a coin. Typically, the obverse features a prominent design, often national symbols or historical figures, which is usually what one sees first. The reverse, or the "tail" side, often carries a secondary design. Understanding these terms will change how you view each coin, appreciating every angle and artwork.

"Edge" might seem self-explanatory, being the outer border of a coin, but there are intricacies to consider here too. Some coins have lettered edges, which can help protect against clipping or shaving off pieces of precious metal, a common practice in earlier times to cheat on the amount of metal in a coin. Others might have reeded edges, consisting of those vertical grooves, which provide their tactile feel and added uniqueness. Grading is an essential facet of coin collecting, denoting the condition and value of a coin.

Terms like "Fine" (F), "Very Fine" (VF), and "Extremely Fine" (EF) describe various states of a coin's preservation. An "Uncirculated" (UNC) coin shows no wear at all, but might still have marks or fading from being in contact with other coins. Becoming fluent in these grades involves not just memorizing definitions but developing an eye for the subtle differences between them.

Another key concept is the "mint mark," a small letter (or letters) on a coin indicating where it was minted. Collectors cherish certain mint marks due to their rarity or the historical context of the issuing mint; for example, coins minted in Carson City (marked with "CC") are often highly prized due to the mint's brief operational period.

Speaking of rarity, "mintage" refers to the number of coins that were produced during a particular time frame. Coins from a low-mintage year can often be more valuable, as they are harder to find—supply and demand at work in the numismatic market.

Imagine, for instance, you are at a coin show, hearing seasoned collectors talk about their latest "key date" acquisitions, or perhaps discussing the "bullion value" of certain pieces. A "key date" refers to coins that are considered essential due to their rarity or significance within a series. "Bullion value" means the market value of the precious metal in the coin, which can fluctuate based on global market prices.

This brief dive into the language of numismatics is more than academic; it's your first step into a broader world of not just collecting coins, but appreciating them as gateways to history, art, and economics. The dialogue among collectors does more than facilitate transactions; it deepens the shared passion for this timeless hobby, knitting newcomers and seasoned experts into a community bound by the love of collecting.

TYPES OF COIN COLLECTIONS

One of the most traditional approaches to coin collecting involves assembling a series based on a specific theme. Thematic collections might focus on coins from a particular historical period, such as Roman coins, which tell tales of emperors and empires, or coins from the Renaissance, reflecting the art and culture of the era. Others might concentrate on geographic origins, collecting coins from every country they visit or from specific continents.

The stories coins tell through such thematic collections can be profoundly personal. Imagine a veteran who begins collecting coins from every major conflict the United States participated in, or a teacher developing a collection that illustrates the evolution of European currencies before the Euro to use as a teaching tool in history classes. Each collection carries a narrative, a personal connection to the broader world, and its historical currents. Another popular collecting strategy centers on numismatic completeness.

This might involve gathering every date and mint mark within a specific coin series, such as the Lincoln penny. This approach appeals deeply to those who appreciate consistency and completeness, providing a clear and structured goal. The chase for the elusive missing piece, such as the famously rare 1909-S VDB Lincoln penny, adds an element of treasure hunting that many collectors find irresistible.

There's also the allure of variety-based collections, which focus on coins that have errors or peculiar variations. These anomalies can be as simple as a double die error, where elements of the coin's design appear twice due to a misalignment during pressing, or as complex as a planchet flaw that results in unique and unexpected patterns. Collectors of these varieties often develop an eagle eye for details, reveling in the tiny imperfections that make these coins amongst the most prized.

Investment-oriented collections represent another category, driven by the potential financial return. Collectors here are often on the lookout for coins made of precious metals like gold and silver, or those rare and historical pieces that are likely to appreciate in value over time. While financial gain can be a significant benefit, many in this sect also grow to love the history and artistry of their investments, deepening their appreciation of numismatics beyond mere economic terms.

Commemorative collections are yet another niche, focusing on coins issued to honor significant events, people, or anniversaries. These coins are usually issued in limited quantities and are often minted in high relief with elaborate designs that capture the essence of what they commemorate. Collecting these can be like amassing a tangible portfolio of history, each coin reminding us of milestones in human achievement or tragedy.

Perhaps one of the most fascinating types of collections is the conditional collection, wherein the collector focuses on acquiring coins in the best possible condition, or specifically seeks out coins at different levels of preservation. This type of collecting emphasizes the physical state of the coin, appreciating the gradations from worn and weathered to mint condition as distinct qualities that tell the story of the coin's journey through hands, pockets, and years.

The eclectic collector doesn't limit themselves to any single type of coin but collects based on personal appeal. This might lead to a seemingly random assortment of coins, but closely inspected, one might notice a subconscious thematic undercurrent—an affinity for intricate designs or coins of peculiar shapes.

Delving into these paths illuminates a vital aspect of coin collecting: the hobby grows and evolves with the collector. Someone might start with a general interest in silver coins, only to find themselves drawn specifically to the Morgan silver dollars, and later, more deeply, to those minted in a specific year that has personal significance.

The joy of coin collecting, therefore, lies not just in the coins themselves but in the journey they represent—a journey of learning, refining interests, and, perhaps most importantly, discovering a deeper connection with history and the wider world. As you build your collection, it becomes more than just accumulated metal; it evolves into a curated exhibition of your personal journey through the world of numismatics. Whether driven by aesthetic pleasure, historical interest, investment, or a combination of these, each collection is as unique as the individual who curates it. This diversity not only enriches the hobby but also ties collectors to a continuum of both numismatic tradition and innovative exploration.

PART II: IDENTIFYING AND UNDERSTANDING COINS

4. Identifying Coins

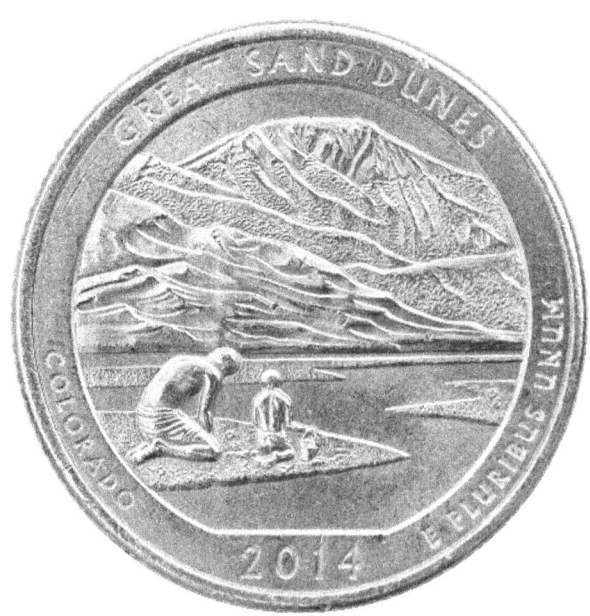

Reading Coin Details: Dates, Mintmarks, and Inscriptions

Deciphering the Date

The date on a coin is typically the first identifier you'll notice. It tells you when the coin was minted, providing a historical context that is indispensable. For instance, a coin from 1796 holds not just the value of the metal and craftsmanship but also a fragment of the world as it was in the year of its creation—the leaders, the conflicts, the cultural norms.

Understanding the era of each piece allows you to build connections not just within your collection but also across the broader sweeps of history. Moreover, certain years signify special mintages or rare batches. For example, the 1909-S VDB Lincoln Wheat Penny is exceedingly rare and valued due to its limited mintage and the unique combination of features it bears.

Unraveling Mintmarks

Mintmarks, those small letters typically found on the reverse (or in some cases, the obverse) of a coin, tell us where the coin was minted. Each mark is a doorway into a deeper understanding of its production and scarcity.

Consider the difference between a coin minted in Philadelphia (often bearing no mintmark) and one from Carson City, denoted by a "CC". The latter mint operated for a brief period and minted fewer coins, thus coins from Carson City are generally rarer and carry a higher collector's value.

The journey of gaining knowledge about various mintmarks is thrilling, as with each letter, your grasp of the geographical history and production spreads across the U.S. minting history.

Interpreting Inscriptions

Inscriptions, including phrases, names, or denominations, provide narrative layers. They are like the dialogue in a novel, revealing intentions, commemorations, or ideological messages. The famous inscription "E PLURIBUS UNUM" (Out of many, one) found on many U.S. coins, offers a glimpse into the foundational ethos of the country. Every inscription on a coin is an opportunity to delve deeper into the cultural and societal values of the time when it was minted.

By paying close attention to these inscriptions, collectors can not only understand more about the coin's origin but also the historical context in which it was created. Inscriptions can sometimes denote special editions or commemorative issues, like the Latin phrases found on many British coins, which can often be linked to significant national events or reigns of monarchs.

Tools of the Trade

While your eyes and a magnifying glass can be sufficient for most, serious collectors invest in specialized tools. A good quality loupe can reveal hidden details that are invisible to the naked eye, allowing for deeper analysis and appreciation of minute features that could potentially distinguish a common coin from a rare specimen.

Using calipers for measuring diameter and thickness can also aid in identifying coins that may have been clipped or worn down from circulation, potentially mistaking them for another denomination or variant.

Engaging Stories Behind the Details

The journey of a coin from mint to collector's inventory is fraught with potential stories. Take, for instance, the 1943 copper penny—during World War II, most pennies were made from steel due to copper's importance to the war effort. However, a few were mistakenly struck in copper, making them extraordinarily rare today. Discovering such a coin is like uncovering a hidden piece of wartime history.

When you hold a coin, you're not just holding a piece of metal shaped by machinery but a capsule of historical and economic significance. Each detail—be it a date, a mintmark, or an inscription—anchors it to a specific time and place, offering a tangible connection to the past.

Thus, sharpening your ability to read these details isn't just about enhancing your collecting skills. It's about enriching the experience, broadening your understanding of history through the lens of numismatics, and connecting more deeply with the coins you collect.

IDENTIFYING COIN TYPES AND VARIETIES

A beginner might start with familiar coins, like those currently in circulation within their country. However, as one's collection diversifies, so does the spectrum of coin types. From bullion coins, valued for their precious metal content, to commemorative coins, minted to celebrate significant events or anniversaries, each type offers a new window into the complexity of numismatics.

Discovering Varieties - A Closer Look

Delving into varieties, the plot thickens. It's akin to finding out that, within what seemed like a uniform category, there are stories of rarities and anomalies waiting to be discovered. For instance, a U.S. quarter might carry the same face value from one year to another, but a closer look might reveal small differences in how the date is stamped or how high the relief of the engraving sits on the coin's surface.

One famous example is the 1955 double die penny, where a misalignment during the minting process resulted in the doubling of design elements. Such coins strike a chord with collectors not just for their rarity but for their ability to highlight the human aspects of minting—after all, errors are a natural outcome of human endeavors.

The Thrill of the Hunt for Errors and Varieties

The pursuit of varieties is often what transforms a hobbyist into a true numismatist. It's here, in the minute examination and comparison, that one can appreciate the nuances of the craft. Error coins, like off-center strikes or those with die cracks, turn the collecting experience into a treasure hunt, where each finding has the potential to be a significant addition to a collection.

For instance, the discovery of a rare minting error on a well-known coin type can feel like unearthing a hidden gem. These pieces often carry stories not just of the minting process but also of how they were discovered, sometimes years or decades after being released into circulation.

Tools of the Identification Trade

To differentiate and identify these types among the vast flows of metal currency, collectors equip themselves with essential tools and lots of patience. Magnifying glasses, a good light source, and reference books are just the beginning. Advanced collectors might employ digital microscopes and high-resolution photography to document and share their finds with the collecting community, adding to the collective knowledge and appreciation of subtle varieties.

Connecting with History and Community

Through this lens, every coin examined and collected is more than a piece of metal—it's a puzzle piece of civilization's vast, rich history. Collectors often find themselves engrossed in the tales of mint directors, famous engravers, or monumental events that influenced a coin's design or production run.

Moreover, the community of collectors plays a vital role in the journey. Discussions at coin clubs, online forums, and conventions ignite passions and often lead to the discovery of new varieties. Each shared story or tip adds another layer of connection, not just to the coins, but to fellow enthusiasts who provide the support and challenge needed to thrive in this intricate hobby.

Tools for Identifying Coins

Magnification: The Window to Minute Details

A magnifying glass is perhaps the quintessential symbol of detail-oriented investigation, and in coin collecting, it's indispensable. When examining a coin's features—its inscriptions, mintmarks, and even its flaws—a magnifying tool provides a window into the finer points that define a coin's identity and value.

The typical recommendation is a loupe with 10x magnification, which strikes a balance between detailed scrutiny and ease of use. Such a tool illuminates subtleties like small mint errors or subtle wear patterns that could be invisible to the naked eye but are crucial for grading the coin's condition.

Lighting: Illuminating the Past

Lighting is another cornerstone in the numismatist's toolkit. Without appropriate lighting, even the most powerful magnifying tool cannot reveal the details that distinguish a common coin from a rare gem. A portable, adjustable, and soft light source can highlight the relief and texture of coins, showing off details that may be lost under harsh artificial lights.

Furthermore, experimenting with different angles of lighting can help accentuate minute details. Raking light—that is, light positioned at a low angle—can be particularly effective in revealing subtle surface deviations like bag marks or hairlines.

Digital Technology: Modern Tools for Ancient Coins

Advancements in technology have gifted collectors with a suite of new tools. High-resolution digital microscopes have become increasingly popular for their ability to capture close-up images of coins which can be shared and examined on larger screens, providing insights not just into a coin's condition but also into aspects like metal flow lines and die varieties.

Moreover, digital calipers can offer precise measurements of a coin's diameter and thickness, assisting in the identification process especially when variances are minute and critical for accurate classification.

Cleaning and Handling Gear: Safeguarding Your Collection

The integrity of a coin is paramount in numismatics. Tools for proper handling and cleaning ensure that coins are not just identified accurately, but are also preserved in their current state.

Soft, lint-free gloves are crucial for handling coins, as they prevent the oils from your skin from tarnishing or corroding the metal.

For cleaning, though it's generally advised to limit this practice, having the right soft brushes and safe cleaning fluids is crucial for those instances when cleaning is necessary. These items allow for the preservation of detail and patina that make vintage coins so valuable.

Reference Materials: Building a Library of Knowledge

No tool is perhaps more valuable than knowledge. Comprehensive reference books, coin catalogues, and online databases are tools as indispensable as any magnifier or caliper. These resources provide vital information on coin types, history, variances, and known issues, which can be the key to identifying an unknown coin or determining its rarity.

Numismatic works can guide newcomers through the basics while serving as an ongoing reference for experienced collectors, bridging gaps in knowledge and providing context that enriches the collecting experience.

Software: Organizing and Analyzing Your Collection

In the digital age, collecting software has become a critical tool for many. These platforms not only help you to catalog and organize your collection but can also connect you with online databases, enabling instant access to a wealth of historical pricing, auction records, and grading information. This access converts solitary collecting into an interconnected pursuit enriched by a global community's shared knowledge and resources.

Embracing Tradition and Technology

Navigating the myriad aspects of coin collecting requires a blend of traditional and modern tools. The tactile pleasure of holding a magnifying glass as you examine an ancient roman coin complements the use of cutting-edge digital imaging and software, creating a comprehensive approach to collecting that honors its historical roots while leveraging contemporary advancements.

5. Grading Coins

Understanding Coin Grades

Firstly, let's consider what coin grading actually involves. At its core, grading is a system used to describe the current state of a coin in relation to its original condition when it was first minted. Over the years, several grading systems have been developed, but today, the universally accepted standard is derived from the Sheldon Scale, which ranges from 1 to 70, with 70 indicating a perfect coin without any signs of wear.

To develop an eye for grading, one must appreciate the significance of the grade. A coin graded with a high number isn't just a piece of metal; it epitomizes the mint's craftsmanship, the historical context, and the care it's received through the decades or centuries. Coin enthusiasts revel in the stories each piece can tell — from times of upheaval, celebrations, or everyday commerce.

Picture a 1921 Morgan Silver Dollar. One specimen might have been tightly stored in a safe, seldom seeing the light of day, preserving its lustrous detail and sharp features — a prime candidate for a high Sheldon score, perhaps a 65 or higher. Its counterpart, however, circulated from hand to greasy hand, acquiring scratches and losing its finest details in the recesses of its design, likely grading around 15.

This disparity in grades fundamentally affects each coin's tale and market value. Collectors might prefer the higher-graded coin for investment purposes, prominently displaying it as a showpiece, while the lower-graded coin might appeal to a hobbyist more interested in the coin's historical journey and accessibility.

Grading isn't just about assigning a number; it's about observation and understanding the subtle indicators of wear and tear. High points of a coin often show wear first. For instance, on many coins, the hairlines on a portrayed figure or the eagle's breast on the reverse side are analyzed to gauge the level of detail, which drastically influences the grade. Learning to spot these early signs of wear can help collectors prevent overestimated investments and can enhance one's ability to scrutinize purchases with a professional's eye.

However, handling coins for grading purposes demands carefulness. The act of touching can itself affect the surface, so enthusiasts often use gloves and handle their treasures by the edges, preserving the integrity so carefully inspected. Here's a practical tip: using a magnifying glass or a loupe provides a better view of potential defects such as scratches, dings, or the subtler nuances of fading luster, all of which are pivotal in grading.

To understand grading deeper, let's consider the process of third-party grading services, which play a pivotal role in the coin collecting ecosystem. Companies like NGC or PCGS are considered the gold standards in coin grading. They provide not only an impartial assessment of a coin's grade

but also encapsulate the coin in a tamper-proof holder, further preserving its condition and enhancing its credibility and tradeability in the market. The unbiased nature of third-party grading provides a common ground for transactional trust among strangers in the numismatic world.

Indeed, mastering coin grading does more than just aid in determining a coin's market value; it enriches the collector's journey, allowing a deeper connection with the pieces, understanding their pasts, and predicting their futures. As collectors, digging deeper into the world of grading fortifies our hobby's foundation, turning a casual interest into a passionate pursuit for excellence.

THE GRADING SCALE: FROM POOR TO MINT STATE

The grading scale, which ranges broadly from Poor (P-1) to Mint State (MS-70), is a foundation that supports the entire edifice of numismatics. It provides an indispensable framework that guides collectors in evaluating a coin's condition and hence, its value and collectability.

At the lowest rung of our grading ladder, we encounter coins rated as Poor (P-1). A coin in this category is barely recognizable; details are so worn that one might only be able to make out some of its contours or larger designs. Although often overlooked by many collectors, coins graded as Poor can still carry significant historical value. Picture a coin from the Roman Empire, worn down over millennia, its inscriptions faded beyond recognition but still an evocative relic from a distant past.

Progressing slightly higher, we reach Fair (FR-2) and About Good (AG-3). These coins show parts of their design, but they are faint, heavily worn, and lack any substantive detail. They serve as humble reminders of the coin's journey through hands, purses, and pockets across the years.

As we tread further along, we discover Good (G-4), Very Good (VG-8), and Fine (F-12). Here, the coins start revealing more of their heritage. Maybe we can see the outline of a monarch, the suggestion of a ship, or the faint script of an inscription that hints at a richer story. These grades begin to reflect coins that, despite considerable circulation, have held onto markers of their creation sufficiently to ignite the imagination and speculation of those who hold them.

Continue the ascent and you encounter Very Fine (VF-20) coins. Such pieces possess enough detail to appreciate the artistry involved in their minting. Key features like hairlines, costumes, and other elements are worn yet discernible. Many collectors prize coins at this grade for their balance of historical value and aesthetic appeal.

Extremely Fine (XF-40) coins welcome us with even clearer features, reduced wear, and more vivid depictions of their era's artistry. They act almost as storytellers, giving the collector a clear image of the mint's intent and the engraver's skill.

As we approach the pinnacle of our grading narrative, we meet the About Uncirculated (AU) coins, which come in grades 50, 53, 55, and 58. These are the nearly-heroes of their kind. They have maintained much of their mint luster and show only traces of wear at the highest points of their design. Collectors who hold an AU-rated coin witness a snapshot in time, a piece nearly as fresh as the day it was struck, bar the light brushstrokes of history.

Finally, we reach the zenith, the Mint State coins, graded from MS-60 to a perfect MS-70. Each step up within this category reflects subtle improvements in terms of luster, the presence of blemishes, and overall appeal. An MS-60 coin, while free from wear, may still bear numerous marks or hairlines. Climbing up towards MS-70, each grade decrease in flaws enhances the coin's brilliance and incredibility. An MS-70 coin is considered perfect, a flawless gem with no imperfections even under magnification, representing not just a monetary achievement but a pinnacle of numismatic pursuit.

THIRD-PARTY GRADING SERVICES

Let's imagine a scenario where Paul, a seasoned collector with a penchant for rare coins, stumbles upon an exquisite 1916-D Mercury Dime—a coin known for its rarity and demand among collectors. The condition appears excellent, but the stakes are high, and the nuances in grading are subtle yet financially significant. Here enters the pivotal role of a third-party grading service. Services like Numismatic Guaranty Corporation (NGC) and Professional Coin Grading Service (PCGS), among others, offer more than just a grade; they provide a security blanket of sorts. When Paul submits his dime for grading, it undergoes a meticulous examination by multiple professionals to ensure a consensus on its grade. This process involves assessing its luster, strike, and wear, among other criteria. But the role of TPGs extends far beyond these technical evaluations.

Once graded, Paul's coin is encapsulated in a tamper-evident, protective holder—a process known colloquially as "slabbing." This not only preserves the coin's condition but also assures any potential buyer of its authenticity and grade, as verified by reliable professionals. The label inside this slab provides vital information such as the coin's denomination, grade, attribution, and other pertinent data, confirming the coin's identity and quality in a glance.

Imagine now, a buyer from across the country or even from another continent who shows interest in this Mercury Dime. The presence of a third-party grading not only elevates his confidence in the described condition of this coin but also diminishes his purchase risk. Such is the power of TPGs—they transcend geographical and communication barriers in the collector's market, creating a platform of trust and reassurance.

Further embracing our narrative, consider the emotional relief and excitement Paul experiences, knowing that the true value of his rare dime is duly recognized and that he can command a price that aligns rightly with its grade. However, the tale of third-party grading services isn't without its nuances.

Choosing between different TPGs often comes down to recognizing their particular strengths. For instance, some may specialize in ancient coins while others might be renowned for their modern numismatic advancements. The credibility and recognition of each TPG in the collector community also play a crucial role. Collectors like Paul often prefer services that are members of the Certified Coin Exchange or subscribed to standards set by the Professional Numismatics Guild, assuring ethical and professional conduct.

But the narrative extends beyond just selecting a grading service. Collectors must understand the grading philosophy and consistency of a service, which can vary. Coins may occasionally receive slightly different grades if submitted to different services or re-submitted to the same service over time. This level of subjectivity and variability is a sophisticated subplot in the grading story, highlighting the art more than the science of numismatic grading.

In our journey with Paul and his Mercury Dime, once authenticated and graded, his coin not only gains in financial worth but also joins a registry of graded coins. These registries, maintained by the TPGs, further enrich the lore of collected coins, allowing collectors to rank and compare their collections in a competitive yet communal setting.

Lastly, the encapsulation mentioned earlier comes with a unique registration number, which can typically be verified on the grading service's website. This feature introduces an additional layer of narrative—the digital footprint of a coin's certification journey, accessible to collectors, dealers, and historians alike, providing a transparent track record that contributes to the lore and legacy of each graded coin.

PART III: BUILDING YOUR COLLECTION

6. STARTING YOUR COLLECTION

PICKING YOUR FOCUS: TYPES, THEMES, AND ERAS

Deciding on a Type-Based Focus

Coin collecting often starts with a fascination for a particular type of coin. For some, this can be as broad as collecting cents or as specific as zeroing in on Morgan silver dollars. A type-based focus often attracts beginners because it offers a clear, manageable path to follow. Envision a collector whose childhood fascination with a Buffalo Nickel at a flea show spurred a lifelong pursuit of every variant of that coin. Such a focus does not merely involve gathering one of each kind but appreciates the minutiae—the slight variations and minting errors that make each coin unique.

Themes That Tell a Story

Theme-based collections can be particularly exciting because they cross boundaries of geography and time, bound only by the narrative you wish to weave through your collection. You might choose to collect coins related to significant maritime explorations, featuring ships and explorers. Each coin in this collection adds a chapter to a global tale of adventure and the unknown.

Consider the thematic collector who seeks coins from every Olympic event featuring specific sports. Each piece in their collection celebrates human physical achievement and the global unity these games promote. Not only do these coins hold value in their rarity or metal content, but they intrigue with the stories they encapsulate, the design and inspiration behind them making each one a tiny work of art.

Chronological Collections: An Era to Explore

Some collectors are drawn not to what coins depict or their types but to the periods they represent. Chronological collecting can be a thrilling chase, as it often requires understanding historical contexts—a Victorian era penny or a Byzantine solidus speaks to the collector about the age it was minted.

Imagine you decide to focus on the Renaissance period, collecting coins minted in various principalities of Italy. Each coin not only comes with its history of craftsmanship but also stories of dukes and battles, innovations, and intrigues that shaped modern Europe. This method of collecting does more than catalog coins; it offers a lens through which history is viewed, understood, and appreciated.

Picking a Focus: Practical Considerations

While passion is a significant driver in choosing a focus, practical considerations play a crucial role in this decision. Availability is one of the fundamental factors. A focus that is too narrow may lead to frustrations if coins are excessively rare or expensive. Conversely, a focus that is too broad might

lack the coherence that can make a collection meaningful and manageable.

Budget also influences focus. Some types of coins, especially ancient or rare specimens, can command high prices on the market. If your budget doesn't stretch to gold Roman aurei, your focus might need to shift toward more plentiful, though no less interesting, bronze denominations. Another aspect is access to resources, which includes available literature, communities of collectors with similar interests, and potential acquisitions at coin shows and auctions. A focus with abundant resources can ease the learning curve and increase the opportunities to enhance your collection.

The Evolving Nature of Focus

A compelling aspect of coin collecting is that your focus can evolve as you delve deeper into the hobby. It's not uncommon for collectors to start with a general interest and gradually specialize as they uncover what truly fascinates them. Perhaps a thematic collector of transportation on coins might narrow their focus to aviation-related coins, captivated by the innovation and adventure that each piece portrays.

In other instances, what starts as a narrow focus might expand as the collector's interest and budget grow. A collector of post-World War II European coins might extend their collection back to the interwar period, seeking connections and contrasts that enrich their understanding of the era.

SETTING A BUDGET

Before setting any numbers, it's essential to take a holistic view of your financial situation. Just as a meticulous gardener assesses the soil before planting, a collector must understand their fiscal environment. How much of your disposable income can you comfortably devote to your hobby without affecting your basic financial security and obligations? This also means anticipating future expenses that might not be directly related to coin collecting but could impact your overall financial flexibility, such as family commitments or planned large expenditures.

Establishing a Flexible Budget

Once you have a clear picture of your financial boundaries, the next step is to define a flexible yet defined budget for your collecting activities. Consider allocating a certain percentage of your monthly disposable income to coin collecting. This method provides a variable that adjusts with your financial state, ensuring sustainability.

However, the flexibility also comes with the requirement to reassess and adjust. For instance, if you encounter a must-have coin that stretches beyond your monthly allocation, having a buffer or a contingency fund within your annual budget for such splurges can be invaluable.

This fund should be built slowly over time, earmarked for those rare, not-to-be-missed opportunities.

Prioritizing Purchases

With the budget set, prioritization is your next crucial step. In the vast world of numismatics, the "right" coins are not merely the expensive or rare ones but those that add value to your collection in meaningful ways. Prioritizing might mean choosing a coin that fills a significant gap in your thematic collection over a potentially more valuable but less relevant piece.

This prioritization can be particularly challenging during auctions, where the thrill of the moment can overshadow your strategic goals. It's here that your budget plays a critical role, serving as a point of reference against which you can measure the impulse to bid. Always ask yourself whether a potential purchase fits within your broader collecting theme and strategy, and whether it aligns with your budgetary constraints.

Tactical Allocation Based on Collection Goals

Different stages of your collecting journey might require different allocation strategies. For instance, in the initial stages, you might allocate more to acquiring reference materials, tools for coin maintenance, and less expensive but foundational pieces for your collection. As your collection matures, your allocation might shift towards rarer, higher-value pieces.

A seasoned collector might advise you always to allocate funds for unexpected opportunities. The numismatic market is dynamic, with rare coins appearing sometimes unexpectedly. Rather than rigidly sticking to a predetermined purchase list, a portion of your budget should be reserved for serendipitous finds that enhance your collection significantly.

Long-Term Financial Planning in Coin Collecting

Long-term planning is as crucial in coin collecting as in any serious investment. Think of your collection as a portfolio, one that requires not just expenditures but also management and growth strategies. This includes ensuring your collection is insured, considering how acquisitions might be financed if necessary, and understanding the resale value of coins, should you decide to reallocate part of your collection.

Particularly astute collectors also plan for how their collections will be handled in the future. Setting aside resources for eventualities such as the conservation, sale, or donation of your collection can ensure that your numismatic legacy is preserved and respected.

Finally, let's not neglect the emotional aspect of budgeting—coin collecting is a passion as much as it is a financial venture. The satisfaction and joy derived from acquiring a new piece or completing a subset of your collection offer intangible returns that are just as vital as the financial ones.

FINDING YOUR FIRST COINS

Your initial foray into acquiring coins usually starts close to home. For many, the quest begins with perusing their own or their family's leftover foreign currency from travels, or examining old coins that have been tucked away in drawers and perhaps forgotten. These familiar avenues can often yield surprisingly interesting finds. There's a certain charm in discovering that what you already own has historical or aesthetic value, or better yet, sparks a deeper interest in specific types of coins.

Engaging with Local Coin Shops

Local coin shops are treasure troves of both coins and expertise. The tactile experience of browsing coins in person, discussing with knowledgeable dealers, and learning about what you're buying is invaluable for a novice collector. Engaging with shop owners can provide insights into the nuances of coin grading, condition, and market value, equipping you with knowledge that goes beyond the price tag.

Imagine this scenario: you walk into a local shop wanting to start a collection of Roman coins, and there, right in the glass case, is a small but intriguing collection that has just been acquired from an estate sale. The coins are varied, each telling a story of ancient marketplaces, long-forgotten festivities, or the daily grind in the Roman world.

Exploring Online Auctions and Marketplaces

The digital realm offers another rich hunting ground for your first coin purchases. Online auctions and marketplaces expose you to a broad array of choices that can be unavailable locally. Here, the key is to arm yourself with research and a judicious mindset. Learn to evaluate listings critically—check seller ratings, read item descriptions thoroughly, and always be cautious of deals that seem too good to be true. Participating in online forums and networks can also help you assess the value and authenticity of coins before making a purchase.

For instance, suppose you've decided to collect coins minted during the reign of Queen Elizabeth II across the Commonwealth realms. Sites like eBay or specialized numismatic online auctions could offer the variety you're looking for, allowing you to compare pieces from dealers worldwide.

Coin Shows and Auctions

Attending a coin show or an auction presents a vibrant avenue to acquire your first coins. These events not only provide access to a wide range us of coins but also offer the liveliness of a numismatic gathering. Here, collectors, dealers, and experts converge, making it a fantastic opportunity to learn through immersion. You'll encounter every level of collector, from the novice to the seasoned, and handle coins that you may only have read about. Imagine the pulse of activity at a major coin show—the booths filled with glinting metal, the murmurs of negotiations, the

occasional gavel fall in the auction corner. Here, acquiring your first coins can be a memorable event marked by direct interaction with the broader numismatic community.

Developing an Eye for Coins

As you embark on acquiring your first coins, developing a keen eye for quality and authenticity is crucial. It's about more than just the historical or face value. Every coin is a piece of art; its design, mint markings, and even wear patterns tell a part of its story. Learn to appreciate the finer details: the sharpness of the strike, the luster of the surface, the clarity of inscriptions.

Develop this skill by visiting museums, studying high-quality images in books and online, and learning from more experienced collectors. Each coin you examine adds to your understanding and appreciation, refining your collecting instincts.

Making Your First Purchase

When you're ready to make your first purchase, whether at a local shop, through an online platform, or at a coin show, take a moment to reflect on the significance of this step. This coin or set of coins is the foundation of your collection. Choose pieces that resonate with your chosen theme or focus but remain adaptable as your collection grows.

Perhaps your first purchase will be a modest, circulated coin from a bygone era, chosen for its historical significance rather than its mint condition. Or maybe it will be a more significant investment, a rare piece that is both a cornerstone for your collection and a story to cherish and recount.

Recording and Celebrating Your Acquisition

The final part of acquiring your first coins is documenting and celebrating your new acquisitions. Record the details of each coin—its history, how you obtained it, its characteristics, and why you chose it. This record will be invaluable as your collection grows and evolves.

Then, take a moment to celebrate. You've started a journey that could last a lifetime, one that may pass through hidden alleys of history, traverse oceans, and uncover stories told in metal and minting. Each coin you add from here builds on this initial moment, creating a tapestry of numismatic intrigue and historical wealth.

7. EXPANDING YOUR COLLECTION

ADVANCED COLLECTING STRATEGIES

Navigating the coin market requires a bit of foresight and a lot of research. Keep in mind trends can be fleeting or long-lasting, influenced by a variety of factors such as historical anniversaries, changes in metal prices, or even societal shifts in the interest towards certain eras or themes. For instance, coins from the Byzantine era may spike in interest during an anniversary year of the fall of Constantinople.

Engage with the market not just as a buyer, but as an observer. Follow auction results, read numismatic publications, and join discussions on online forums and at coin clubs. This ongoing engagement helps you anticipate market trends, making it easier to buy wisely and sell strategically.

Specialization is Key

One effective strategy for elevating your collection is specialization. Select a niche—be it coins from a specific country, era, or featuring a certain type of artwork. This focus allows for deeper research and a more profound understanding of the subset, which in turn can lead to more informed buying decisions.

For instance, consider Malcolm, a collector I once knew who specialized in pre-World War I German mark coins. His initially broad interest in 20th-century European coins narrowed after he stumbled upon a rare 1913 'Frederick the Great' 3-mark coin. His excitement over this particular find led him to specialize, and as he focused his research and purchases, Malcolm became an acknowledged expert in that narrow field. His collection, though specific, was deeply nuanced and highly valued.

Building Relationships with Other Collectors

As your collection grows, so too should your network. Relationships with other collectors can prove invaluable. Fellow enthusiasts not only provide social camaraderie but can also offer insights into aspects of the hobby you are less familiar with. More importantly, these relationships can lead to trades and purchases that might not have been possible otherwise.

Consider joining more specialized coin clubs or online groups. Attend national and international conferences, not just local shows. These are the places where serious collectors gather, and the connections made here can enhance your collection in ways that going at it alone never could. For example, a collector named Lisa was able to complete her collection of Victorian era medallions through a contact she met at a convention in London.

Consider Long-Term Investments

Advanced collectors also need to think in terms of long-term gains—financially, educationally, and

personally. Part of this strategy might include investing in rarer, more expensive coins that have a history of increasing in value. While such purchases may require a significant upfront cost, their long-term value can be substantial.

When considering long-term investments, seek out coins that have a solid history of demand and limited availability. Be wary, however, of market highs—buying during a peak can mean paying a premium that might not be recouped for many years, if at all.

Embrace Digital Tools

Technological advancements have transformed coin collecting. Digital tools can provide access to coin auctions worldwide, databases for research, and even apps that help with organizing and cataloging your collection. Embracing these tools can streamline the management of your collection and enhance your access to information, making it easier to implement more sophisticated strategies in both buying and selling.

Additionally, utilize image databases and high-quality scanning tools to examine coins closely without needing to see them in person. This capability is particularly useful when considering purchases from international sellers, where the logistics of viewing coins firsthand can be challenging.

Ethical Collecting

Lastly, commit to ethical collecting. This involves ensuring the authenticity of coins before purchasing and refusing to engage in the trade of illegally obtained artifacts. Ethical collecting also means considering the cultural significance of coins, particularly those that might be considered national treasures.

The advanced strategies mentioned do not merely expand your collection—they enrich your entire experience as a numismatist. Through the application of these methods, you grow not only in the scope of your collection but also in knowledge and appreciation of the multitude of stories that each coin tells. Remember, advanced coin collecting is not just about acquisition but also understanding, curating, and contributing to the historical narrative that numismatics offers.

BUILDING A THEMATIC COLLECTION

The selection of a theme is akin to choosing the lens through which you will view your collection. Themes can be as broad as coins from a specific country, or as narrow as coins depicting a certain historical figure. For instance, you might be enthralled by the Renaissance period, leading you to collect coins minted during that era. Alternatively, the wildlife enthusiast might focus on coins featuring national animals across the globe. The crucial part is that the theme should captivate your interest. It should be something you are passionate about. This passion will fuel the required research, hunting, and networking needed to grow and maintain your collection.

Historical Significance

Expanding a thematic collection often involves delving deeper into history than one might initially expect. Consider a collector named Elizabeth, who started collecting coins bearing the likeness of Queen Elizabeth I. As she explored these coins, her interest was piqued by the broader Elizabethan age—its politics, culture, and even the exploration feats of that era. Her collection became a gateway to understanding the age of exploration as key 'New World' discoveries were commemorated in the coins of the period.

Artistic Expression

Coins are miniature art pieces, their designs reflective of the cultural and artistic sensibilities of the time they were minted. Collecting thematically can also be an exploration of art history. A collector focusing on Soviet-era coinage, for example, may note the stark contrasts in artistic style as political regimes changed, reflecting the shift from royalist to communist imagery and then to modern designs post-USSD dissolution.

Building the Collection

Once you have your theme, building your collection involves strategic acquisitions. You must decide whether to go wide—collecting every coin that fits the thematic criteria; or deep—focusing on rare or significant coins that define the theme. The thrill of the hunt can be found in auctions, estate sales, coin dealer offerings, and trades with fellow collectors. Remember to document where each coin comes from and its story. This documentation enriches the collection, giving it context and depth that can be appreciated both by you and by others who may view your collection.

Networking

Part of the joy of thematic collecting is the community you build along the way. Engaging with other collectors who share your interest can provide not only camaraderie but also knowledge and trade opportunities. Attending thematic exhibits at coin shows or joining specialized online forums can deepen your understanding and expose you to coins you might not have found on your own.

Utilizing Technology

Modern technology offers tools that can immensely enrich the thematic collector's strategy. From high-resolution digital imaging allowing for the study of minutiae without direct handling of the coin, to online archives providing historical context, the digital age is a boon for collectors. Software for cataloging can help manage your collection, tracking acquisitions, trades, and sales linked to your theme.

Challenges and Rewards

Every collector's journey comes with its set of challenges. In thematic collecting, one major challenge's the limitation in scope—it's possible to hit a point where it becomes incredibly tough to find new additions that fit your strict criteria. However, this scarcity can also lead to greater rewards as each new find can feel like uncovering hidden treasure.

Another challenge is the potential for higher costs. Rare thematic coins can command premium prices, but the joy and satisfaction derived from acquiring a long-sought-after piece can make the investment worthwhile. Plus, the focused nature of your collection can often lead to a greater overall value, both in monetary and historical/artistic terms.

Networking with Other Collectors

Numismatics is a field where knowledge is as precious as the coins exchanged. Establishing relationships with other collectors can lead to more than just transactions. It's about creating a dialogue, learning from experiences, and often, gaining insights into areas of the hobby you haven't explored. Each collector brings a unique view to the table, influenced by their own experiences, research, and interests.

Sharing and Acquiring Knowledge

Consider a scenario where you specialize in obscure medieval coins, but you meet someone whose expertise is 20th-century commemorative coins. This exchange of knowledge can broaden your understanding and might even inspire a new direction for your collection. Networking isn't just about getting something from someone else; it's a mutual exchange that can be academically enriching.

The Thrill of the Hunt

Networking can turn the often-solitary act of searching for coins into a shared quest. When you develop relationships with other collectors, your network will occasionally remember your specific interests and reach out when they encounter something that fits your collection. Conversely, if you know a fellow collector is looking for a particular piece, and you happen upon it, you can share in the thrill of their discovery by notifying them.

Coin Clubs and Online Communities

Joining a coin club is one of the most straightforward ways to meet like-minded individuals. Clubs often hold meetings, arrange guest speakers, and sponsor coin shows. Participation in these events can provide a platform for sharing, trading, and discussing coins with enthusiasts and experts alike. Additionally, online forums and social media groups offer a way to connect with a global numismatic community. Many collectors find these platforms invaluable for advice, trading, and staying updated on market trends and news.

Imagine a collector, Sarah, who moved to a rural area where no local coin clubs exist. By joining online forums, Sarah remains actively engaged in the numismatic community—buying, selling, and learning—thus continuing to grow her collection and her knowledge.

Building Trust in Trades and Purchases

As with many collectibles, the numismatic community relies heavily on trust, particularly in trades and sales. Building long-term relationships with other collectors can create a network of trusted individuals who can vouch for the authenticity and value of coins. Such trust is invaluable, especially in an era where online transactions can be fraught with misrepresentations or frauds.

Stories from the Trenches

Every collector has stories of near-misses, incredible finds, or lessons learned the hard way. These narratives are more than just entertainment; they're a form of shared history that can offer insights and warnings for your collecting journey. For instance, a seasoned collector might share a story about a counterfeit scare that teaches you what to look for in future purchases.

The Generational Pass-Down

Coin collecting is often a generational passion passed down from older family members to the younger ones. Through networking, this generational wisdom can extend beyond familial lines to younger collectors within the community. Seasoned collectors often take pride in mentoring newcomers, passing down not just knowledge but also philosophies and ethical considerations that are central to the hobby.

The Role of Mentorship

In an ideal networking scenario, mentorship comes into play. Experienced collectors can guide you through complex areas, such as grading or spotting counterfeits. They can help shape your collecting strategy, improve your negotiating skills, and offer you first dibs on coins from their collections that suit your theme or focus.

Networking in Action

Let's say a novice collector, John, expresses interest in U.S. Civil War tokens at a coin club meeting. An older member, Ellen, overhears and introduces herself, revealing her extensive collection of

civil war tokens. They form a connection, and Ellen invites John to view her collection, offering insights into the historical context of each piece. For John, this relationship not only expands his understanding but also helps him make more informed choices on what tokens might enhance his fledgling collection.

Coin collecting, at its core, is about connecting the past with the present, a quest made richer with every interaction. As you network with other collectors, you're woven into a tapestry of shared narrative threads—a community that not only helps grow your collection but deepens your appreciation of history and the art of collecting. Whether through face-to-face interactions or digital communications, each connection you make is a step further into the vast, intricate world of numismatics.

8. BUYING COINS

WHERE TO BUY: AUCTIONS, DEALERS, SHOWS, AND ONLINE

The Auction Adventure: Excitement and Opportunity

Imagine the palpable excitement of a coin auction, whether you're attending in person or participating online. The atmosphere is charged, the pace can be breathtaking, and the coins on offer are often of remarkable quality and rarity. Auctions are not merely transactions; they are competitive events that can be both thrilling and rewarding.

For collectors, the primary allure of auctions lies in the quality and rarity of coins available. Many auctions cater to specialized segments of the market, offering pieces seldom seen in other sales venues. Moreover, the potential to acquire coins at or below market value is a significant draw, provided you understand the dynamics of bidding and the market.

A smart approach to auctions involves prior preparation. Reviewing auction catalogs, researching the histories and market values of desired coins, and setting strict budget limits are essential practices. Remember, the excitement of an auction can sometimes lead to impulsive decisions, so maintaining discipline is key to avoiding misguided purchases that do not align with your collection goals or budget.

Dealer Interactions: Building Relationships and Expertise

Working with coin dealers is about more than transactions; it's about building relationships that can enrich your collecting journey. Reputable dealers often possess in-depth knowledge about numismatics and are instrumental in finding specific coins or advising on potential additions to your collection.

When choosing a dealer, consider their reputation, expertise, and the ability to provide authentication and warranties for their coins. A trustworthy dealer will be transparent about coin grades and prices and will be willing to discuss their rationale for a coin's valuation. Many seasoned collectors maintain ongoing relationships with trusted dealers, benefiting from personalized advice and first consideration of new acquisitions that suit their collections.

It's also prudent to attend dealer interactions informed and prepared. Much like preparing for an auction, you should research coins and market trends beforehand to engage in discussions knowledgeably. This prep work underscores your seriousness as a collector and can lead to more fruitful interactions and negotiations.

Coin Shows: A Nexus of Numismatic Activity

Coin shows offer a unique opportunity to immerse yourself in the numismatic community. These events range from small local gatherings to large international expos, featuring a variety of dealers, auction houses, and educational presentations. For many collectors, attending a coin show is as

much about the experience and community as it is about the coins themselves. The primary advantage of coin shows is the ability to browse a vast array of coins in person and make immediate purchases. The tactile experience of examining coins, discussing with sellers, and making decisions on the spot offers a satisfaction that remote buying cannot replicate. Furthermore, coin shows are excellent for networking with fellow collectors and experts, sharing insights, and discovering new collecting avenues.

A strategic approach to coin shows involves planning: researching the event's size, the dealers attending, and the types of coins that will be available. Setting a clear objective for what you hope to find or learn at a coin show will guide your interactions and help manage your time effectively amid the broad offerings.

Online Platforms: Convenience and Reach

In today's digital age, buying coins online has become a staple. The convenience of browsing extensive inventories from the comfort of your home is undeniable. Online platforms range from large auction sites and dealer websites to social media groups specializing in numismatics.

While online shopping provides great convenience and variety, it also requires a cautious approach. The inability to physically inspect coins before purchase necessitates relying on pictures and descriptions provided by the seller, underscoring the importance of buying from reputable sources. Ensure that the platform offers robust buyer protection policies and that the sellers have credible reviews and ratings.

Another advantage of online buying is the ease of comparing prices and researching coins. Many platforms provide access to historical price data and community forums where one can seek advice or read about others' experiences with specific sellers or coins.

All these avenues—auctions, dealers, coin seats, and online platforms—offer different experiences and opportunities. Your choice will depend on several factors, such as the type of coins you're looking to purchase, your comfort level with each purchasing method, and the depth of experience you wish to have with the numismatic community.

Cultivating a balanced approach, utilizing all these avenues over time, can maximize both the joy and effectiveness of your collecting pursuits. Each platform offers unique benefits, and by understanding and navigating these, you're more likely to enrich your collection and deepen your appreciation for the art and history embedded in each coin you choose.

SPOTTING A GOOD DEAL

Understanding the market value of a coin is foundational in identifying a good deal. This knowledge stems from comprehensive research, which includes studying auction results, price guides, and trade publications. These resources give insights into how particular coins are valued based on rarity, demand, and historical sales data. However, the price listed is not always the price necessary to pay. Market conditions fluctuate, and sometimes sellers are motivated by quick sales rather than holding out for maximum return. This scenario presents an opportunity for the informed collector.

Condition and Grading: The Pillars of Coin Valuation

Every seasoned collector knows that the condition of a coin significantly affects its value. A coin in pristine condition is many folds more valuable than its well-circulated counterparts. Grading, therefore, becomes a pivotal skill in recognizing a good deal. Mastery in grading coins involves understanding the nuances that differentiate a very fine (VF) coin from an extremely fine (EF) coin, and so on up the grading scale.

Handling numerous coins, attending grading workshops, and utilizing grading services can sharpen this skill. When you can trust your own judgment about a coin's condition, you can make purchasing decisions with greater confidence, knowing when a coin's market price undervalues its actual condition and potential value.

Rarity and Historical Significance

Rarity does not always correlate with age, but often with how many coins of a particular type were minted and how many have survived. A coin rare in fine condition but more common in lower grades might be undervalued in markets less sensitive to nuances in grading. Historical significance also plays a crucial role, as coins connected to notable historical events or periods can command higher prices. By educating yourself about the broader context of the pieces in your collection, you position yourself to spot undervalued coins that others may overlook.

Psychological Acumen in Negotiations

Negotiation is where keen understanding meets human psychology. Each selling scenario whether at a coin show, an auction, or a private sale, involves different negotiation dynamics. In direct negotiations, it's vital to read the seller's cues and adapt your strategies accordingly. Sellers might be more open to reducing the price if they feel respected and sensed your genuine interest and knowledge about the coin.

The art of negotiation also involves knowing when to walk away—a powerful position that not only saves you from a bad deal but also may prompt the seller to reconsider your last offer. A good deal is often secured through patience and respect for both the coin and the person selling it.

Long-Term Investment Perspective

In spotting good deals, it's advantageous to think long-term. Consider how a coin will fit into your collection's narrative or its potential for appreciation. Some collectors specialize in specific niches, accumulating coins that symbolize a particular era or theme. These focused collections can be highly desirable on the market, often fetching prices well above those of more eclectic collections. Understanding trends in numismatics and predicting future interest areas can also guide your purchase strategy. Coins associated with areas growing in popularity can often be purchased before they reach peak demand, securing them at prices that will seem modest in retrospect.

Emotional Intelligence and Buying Discipline

Lastly, while the thrill of a good find is undeniable, maintaining emotional distance is crucial. Every purchase should align with your collection strategy and budget. It's easy to get swept away in the excitement of an auction or the persuasive charm of a skilled seller. Here, discipline must prevail. Stick to your predetermined criteria and budget to avoid buyer's remorse and ensure each acquisition is a strategic addition to your collection.

AVOIDING COUNTERFEITS AND SCAMS

The cornerstone of every collector's pursuit is authenticity. Recognizing a genuine coin goes beyond mere visual inspection and delves into the subtle craftsmanship and historical context of the piece. This discernment begins with understanding the specifics of minting processes, historical designs, and the materials used during the coin's era of production.

Engaging with reputable resources such as numismatic catalogs and official mint records can provide invaluable insights. Moreover, comparing coins with verified specimens, whether through high-resolution images or in numismatic museums, can sharpen your eye for detail and help you spot inconsistencies in suspect coins.

Counterfeit Clues: Visual and Tactile Signs

Here's where the numismatic detective work comes in. Counterfeit coins often fail to fully replicate the intricate details of genuine specimens. Key indicators include incorrect weights, sounds, and sizes compared to known standards. Additionally, the appearance of the coin's surface might offer clues: overly shiny coins can suggest recent manufacture, while improper aging might reveal discrepancies in patina or wear patterns.

For the tactile examiner, the feel of a coin can also be telling. The edges and relief of a genuine coin have a certain sharpness and precision that counterfeits often lack, as they may use substandard minting techniques.

The Role of Technology in Verification

In today's digital age, technological tools can be formidable allies in the battle against fakes. High-powered magnifiers or digital microscopes reveal minute details often overlooked by the naked eye, such as minute flaws or abnormal tool marks. Additionally, precise measuring devices that gauge dimensions and weight can verify a coin's authenticity with remarkable accuracy.

Moreover, the use of spectrometers, which analyze the metal composition, can be particularly revealing. Many counterfeit coins use base metals which are then plated to appear like silver or gold. A spectrometer test, while more technical and not typically a beginner tool, can definitively pinpoint the elemental composition, confirming whether the material matches that of known genuine coins from the same period and mint.

Safeguards in Transactions: Dealers, Auctions, and Online Platforms

When purchasing coins, choosing the right venue and seller is half the battle in avoiding counterfeits. Reputable dealers, who are typically members of recognized numismatic associations, adhere to strict standards of authenticity and often offer guarantees with their sales. Developing a relationship with trusted dealers can provide you peace of mind while enriching your collection.

Auctions, while offering a diverse array of coins, require a careful approach. Prior to bidding, examine the auction house's reputation and any available lot verification processes. Many prestigious auction houses provide detailed provenance and condition reports, and some also offer viewing days where coins can be physically inspected.

The online world, offering both vast resources and significant risks, demands the highest level of caution. When buying coins online, opt for platforms that offer buyer protection. Prioritize sites that provide clear, detailed photos from multiple angles, along with precise descriptions and verifiable sources of provenance. Be wary of deals that seem too good to be true—they often are.

Building a Network for Safety

Beyond personal vigilance, engaging with the broader numismatic community can provide a safety net. Coin clubs and online forums allow collectors to exchange information about known scams and dubious sellers. These platforms often feature discussions and reviews that can alert collectors to potential dangers before they strike.

Equally, attending seminars and workshops on coin authentication not only bolsters your own knowledge but also connects you to a network of knowledgeable collectors and experts whose advice can be invaluable. They often share personal stories of encounters with fakes, offering practical insights into avoiding similar pitfalls.

PART IV: MANAGING AND PROTECTING YOUR COLLECTION

9. COIN STORAGE AND DISPLAY

BEST PRACTICES FOR COIN STORAGE

Imagine for a moment the fate of a coin left on a seaside boardwalk: exposed to salt air, the thrum of foot traffic, and the relentless touch of sea spray. Now, consider this same coin snugly tucked away in a controlled environment where temperature, humidity, and handling are meticulously regulated—its longevity and pristine condition are significantly increased. Coins are resilient yet profoundly vulnerable relics of metal; their worst enemies include moisture, extreme temperatures, and pollutants that provoke corrosion and tarnish.

The key objective in storing coins is creating a stable environment. Fluctuations in temperature can cause condensation, and alongside high humidity, this environment becomes a breeding ground for chemical reactions on the surface of coins. Ideally, collectors should aim to maintain temperature and humidity levels that mirror those found in museum archives—about 18-20°C with 35-50% relative humidity. While this may sound like a stringent range that demands complex setups, simple solutions like air conditioners in summer, dehumidifiers during rainy seasons, and

consistent thermostat adjustments can be just as effective.

Selecting the Right Storage Materials

Over the years, coin collectors have echoed a common theme of discovering that not all storage containers are equal. Even products marked safe for coins can pose hazards due to the materials involved. For instance, PVC, commonly used in cheaper coin holders, releases a damaging chemical as it degrades, which can create a sticky residue on the surface of coins, known colloquially as 'PVC haze'. This damage is not just unattractive but can significantly reduce the coin's value.

I recall a seasoned numismatist who learned this lesson the hard d way. Enthralled by what seemed like a bargain on bulk coin holders, he later discovered that his entire collection of 19th-century silver dollars had developed a film that obscured their once-mirror finishes. A lesson was learned: always opt for holders made from inert materials such as Mylar or acrylic, that promise safety without chemical interaction over time.

Handling and Access

One of the subtle joys of coin collecting is the tactile connection to history—feeling the weight and smoothness of a coin, tracing the worn edges where countless others have done the same. However, every touch carries the risk of transferring oils or acids from the skin onto the metal, which can initiate corrosion. Handling coins properly involves using cotton gloves and holding the coin by its edges, ensuring that fingers do not contact the faces (obverse and reverse) of the coin.

A fellow collector once shared his method for minimizing unnecessary handling: he uses clear containers for storing his most valuable coins, which allows him to view and enjoy his collection without frequent direct contact. This practice not only protects the coins but also makes them easily accessible for viewing and appreciates their beauty without risk.

Security Considerations

While we often focus on the environmental and physical aspects of storage, security is equally crucial. Coins, especially those rare and valuable, can be irresistible to thieves. A comprehensive storage plan should include both visibility and inaccessibility. Safes or secure display cases that offer both environmental control and lock-and-key or passcode access provide peace of mind.

Personally, I have found that blending security with accessibility can be as simple as a well-placed safe in a home office or even renting a safety deposit box at a local bank for exceptionally valuable pieces. The peace of mind in knowing that your collection is secure allows for greater enjoyment and less worry about potential loss.

Routine Checks and Maintenance

Lastly, establishing a routine for inspecting and maintaining your collection is crucial.

Frequent checks help identify early signs of potential issues such as corrosion, wear, or environmental fluctuations, and are essential for timely interventions. I make it a practice to schedule quarterly reviews of my collection, a tradition that not only aids in maintenance but also provides a scheduled opportunity to revel in the history and artistry each piece represents.

DISPLAYING YOUR COLLECTION

The decision to display a coin collection should be guided by a thematic focus. Just as a curator designs an exhibit to journey through time or ideas, a numismatist might also consider grouping coins to represent specific historical periods, geographical discoveries, or even the evolution of minting techniques. Consider the story of Charles, a seasoned collector whose fascination with nautical history led him to collate coins from shipwrecks. His display, creatively arranged with a map of maritime routes and replicas of ancient ships, not only dazzles the eye but also educates the observer, making the coins more than just metallic curiosities; they become relics brimming with tales of adventure and the high seas.

Choosing the Right Display Options

The heart of displaying coins lies in selecting the proper cases and holders that not only enhance the visual appeal but protect the coins' integrity. Coin capsules, made from clear, durable materials like acrylic, offer both safety and unobstructed views of the coin, thus allowing light to bring out the details in the design without exposing the coin to oils or pollutants. For a more dramatic presentation, floating frames can suspend coins between two transparent flexible membranes, giving the illusion that they are hovering within the frame.

Imagine walking into a room where coins appear to float around you, each piece showcased in a way that seems almost magical. This was the vision of Emily, a collector who employed floating frames to create a light and airy display of her early 20th-century American coin collection. The setup not only drew attention to the uniqueness of each coin but turned her collection into a dynamic part of her living space decor.

Lighting: The Subtle Art of Illumination

Effective lighting transforms a good display into a great one. Directional lights, strategically placed, can highlight the relief and craftsmanship of each coin. LED lights, known for their broad spectrum of temperature settings, can be adjusted to showcase the true color of the coins without the damaging effects of UV light. A well-lit display not only enhances the visual experience but also plays a crucial role in protecting the coins from the dangers of excessive heat and light exposure. I recall how a fellow numismatist, George, dealt with the challenge of displaying his collection of Byzantine coins. These ancient pieces, struck with intricate designs, were showcased

under low-intensity LED lights that highlighted the depth and detail of the coins—a simple yet effective technique that profoundly impacted the display's appeal.

Positioning and Layout

The positioning of a coin collection within a room is just as vital as the display case used. Coins should be positioned at eye level, ensuring that each piece is easily visible without the need to handle or move them. A layout that allows for natural flow and accessibility invites guests to appreciate the collection effortlessly.

Spacing between coins is another crucial consideration. Crowded displays can detract visitors and obscure individual pieces. Adequate space allows each coin's presence to be acknowledged, appreciated, and absorbed without the visual competition from neighboring items.

Interactive and Educational Elements

Beyond aesthetics, a display can be educational. Descriptive plaques or digital screens that provide insights about the coin's history, provenance, and significance can engage viewers more deeply, turning a simple viewing experience into an educational journey. For collectors like Lila, who prides herself on her collection of coins from the ancient Silk Road, incorporating interactive maps and information panels transformed her displays into a narrative experience, inviting viewers to delve deeper into the context behind each piece.

Security Measures

Finally, securing a displayed collection is as critical as any other aspect of its presentation. High quality locks, alarm systems, and strategic room choices can deter theft. Moreover, employing shatter-proof glass and positioning displays away from windows and high-traffic areas can prevent accidental damage.

SAFEGUARDING AGAINST LOSS AND DAMAGE

Consider a friend of mine, Thomas, who owns a remarkable collection of Renaissance-era coins. One humid summer, he discovered, to his dismay, that several coins had begun to show signs of corrosion—small green spots marring the once-immaculate surfaces. This incident underlined an overlooked aspect of coin storage: even indirect factors like climate can pose a risk. Thomas's oversight teaches a valuable lesson in understanding the variety of risks—environmental or otherwise—that can threaten a collection.

Environmental Controls: Combatting Nature's Influence

One of the fundamental ways to protect coins is by controlling the environment where they are stored. Fluctuations in temperature and humidity are among the top culprits in causing damage. Establishing a controlled climate with the use of specialized cabinets or safes that regulate these

factors can prevent most forms of environmental damage. Moreover, collectors should guard against less obvious threats like pollution and sulfur which can be prevalently found in urban settings. Air purifiers and corrosion interceptors can be employed within display cases to create a barrier against these insidious elements.

Enhanced Security Systems: The Shield Against Theft

Collectors like Lydia, who secured her valuable coin collection within a high-tech home safe, underscore the importance of security. Following a near miss when burglars targeted her home, Lydia invested in an integrated security system that includes motion detectors, glass break sensors, and constant monitoring.

For collectors displaying their coins, consider safes certified by Underwriters Laboratories, which offer not just theft protection but also ratings for fire resistance. These comprehensive security measures ensure that coins are not only protected from burglars but also from potential disasters like fires.

Insurance: Your Safety Net

Insurance remains a cornerstone of safeguarding any valuable collection. Standard homeowners' insurance often provides inadequate coverage for collectibles like coins, which necessitates obtaining a specialized policy tailored to the unique needs of coin collectors. This insurance should cover the full value of the collection against all forms of loss and damage.

Navigating insurance can be complex, but the peace of mind it brings cannot be overstressed. Regular appraisals are essential to ensure coverage reflects the current market value, especially as some coins might appreciate over time.

Regular Inspections: The Ongoing Vigilance

Routine checks serve as the collector's ongoing line of defense. Inspecting a coin collection regularly can alert you to early signs of potential damage, allowing you to address issues before they escalate. Consider the practice of Anne, a seasoned collector, who schedules quarterly reviews of her collection. During one such inspection, she identified a small leak in her display case—a prompt discovery that likely saved her collection from significant water damage.

Educating House Members: A Collective Effort

Safeguarding a collection is not a solitary task. It is imperative to educate everyone in your household about the value and fragility of the collection. This awareness ensures that routine activities around the home are conducted with care, especially in households with children or pets. Such was the lesson for a collector friend, Jack, whose young nephew, unaware of the consequences, once used a rare coin as a makeshift screwdriver. This incident could have been mitigated had there been a general awareness in the household about the significance of the coins.

10. Coin Preservation and Cleaning

When and How to Clean Coins

Imagine you've just acquired an old coin, one that's been in circulation long enough to witness the turn of centuries. Its surface bears the marks of its journey: a patina of age, perhaps some grime accumulated through decades of being exchanged from one hand to another. It's tempting to want to scrub away the years to reveal the coin's original luster. But here's where the seasoned collector's wisdom must intervene. The first rule in coin cleaning is a resounding 'if in doubt, don't'. Most coins, especially those that are older or historically significant, are often more valuable in their original, uncleaned state. The patina, that fine layer of toning that coins develop over time, is actually desirable, often enhancing a coin's appeal and authenticity.

"Then why clean a coin at all?" one might wonder. Cleaning is generally reserved for removing harmful residues or substances that could damage the coin over time. Examples are salt from human sweat, which can cause corrosion, or sticky residues from improper storage. The selection of cleaning a coin should always be driven by the need to preserve rather than to beautify.

For those instances where cleaning is justified, the process must be approached with the precision of a surgeon. Gentle is the keyword. For lightly soiled coins, simple air dusting or a soft brush intended for coin cleaning might suffice to remove loose debris without scratching the surface.

For slightly more stubborn dirt or grease, warm water and a mild soap could be used, followed by a thorough rinse to remove any soap residues that might tarnish the metal.

In more complex cases where professional intervention is warranted, it becomes even more critical that the approach is cautious and informed. For instance, a professional may use ultrasonic cleaning, a method that uses ultrasound waves and chemicals to clean coins without physical contact. This technique is reserved for coins where dirt or oxidation is so ingrained that conventional methods are ineffectual.

A personal anecdote here serves as an illustration of both the risks and the right approaches. I recall encountering a rare 19th-century coin that had unfortunately been stored in less-than-ideal conditions. The coin had developed verdigris— a green or bluish deposit appearing on copper, brass, or bronze surfaces exposed to air over time. Leaving the verdigris could lead to further corrosion, damaging the coin's intricate engravings. After much deliberation, I opted for a professional conservator specializing in numismatic preservation. The coin was treated with specific agents that neutralized the verdigris without undermining the underlying metal. It was a delicate balance to strike, but the outcome was a coin that was preserved, rather than merely cleaned.

Let's also consider the tools of the trade. While a plethora of cleaning kits and solutions are available on the market, the indiscriminate use of these can do more harm than good. Abrasive tools or harsh chemicals can leave scratches or alter the surface of the coin, permanently reducing its numismatic value. When choosing cleaning agents, opt for products that are specifically designed for numismatic purposes, bearing in mind that less is often more in the realm of coin cleaning.

PROFESSIONAL PRESERVATION TECHNIQUES

Professional preservation is not merely about keeping a coin free from dust. It encompasses a full array of processes aimed at conserving both the physical and aesthetic aspects of coins that are facing varying degrees of deterioration, or are simply at risk from environmental threats. Let us explore a few narrative-rich explorations into this meticulous world.

Imagine, if you will, the journey of a coin that has been discovered after centuries buried underground. Such a coin, upon discovery, carries with it not just historical value but also a considerable amount of debris and possible chemical reactions that have occurred over the years. Enter the professional conservators, the unsung heroes of numismatics. Their first step often involves a detailed analysis using tools such as magnification devices or even x-rays to determine the exact composition and state of degradation of the coin.

One vivid example is the use of electrolysis in coin preservation. This method is particularly advantageous for coins that have suffered from significant oxidation—a common scenario for ancient coins unearthed from their graves. Electrolysis carefully removes these oxide layers. However, this is a process where exact science meets fine art. The voltage and duration of the electrolysis must be meticulously calibrated. Too strong a current or too long an exposure, and the coin can be irreversibly damaged.

For less dramatic scenarios but where precision is still key, professionals might turn to chemical stabilizers. These special substances are used to halt ongoing chemical reactions that can cause further deterioration of the coin. For example, a coin showing early signs of bronze disease (a condition marked by the outbreak of green spots on bronze coins) might be treated with specific inhibitors that arrest the progression of corrosion without altering the coin's original appearance. Conservationists must also focus on the future by predicting potential degradation issues based on a coin's environment and makeup. This predictive approach might involve creating micro-environments within coin holders that have atmospheres carefully controlled for humidity and gaseous composition. This method can be likened to creating a mini-museum display case for each coin, tailored to its specific conservation needs.

An absorbing tale from the field involves a renowned conservator tasked with preserving a rare coin collection found aboard a sunken seventeenth-century ship. The coins had been submerged in saltwater for over three hundred years, posing a unique set of challenges. The conservator chose a multi-stage process that began with gentle mechanical cleaning to remove the encrustations, followed by chemical treatments designed to stabilize the metal. The coins were then sealed in inert atmospheres—special holders that prevent any external air or pollutants from causing further corrosion.

It's essential, too, for these experts to consider the storage and display of preserved coins. After all, what is the benefit of meticulous preservation if the coin is then improperly displayed or stored, exposing it to elements that could undo all the careful work? Thus, professionals often provide advice or even materials for the long-term storage and display of these valuables, ensuring that light, temperature, and touch do not degrade the coin further.

Furthermore, while professional preservation techniques provide an impressive arsenal to combat deterioration and maintain a coin's splendor, there is also a discussion to be had about when to halt interventions. Sometimes, the best conservation strategy is to maintain the current state of a coin rather than attempting to return it to an idealized form. This conservative approach respects the coin's historical narrative, including its wear and patina, which are authentic markers of its journey through time.

Professional coin preservation is a blend of science, art, and ethics. It requires an in-depth knowledge of materials science, chemistry, and even historical context, combined with a steady hand and a deep respect for the past. Whether a coin collector enlists such services immediately after acquiring a new piece or as part of an ongoing effort to protect a cherished collection, the skills of professional conservators are invaluable.

COMMON MISTAKES TO AVOID

One of the first mistakes often made by both novice and seasoned collectors alike is the impulsive cleaning of coins soon after acquisition. There's an almost instinctive desire to polish and cleanse any old coin to make it shine as it once might have. However, this can irreparably damage the coin's patina or finish. The patina, a layer that develops over years or centuries, can add both aesthetic and historical value to the coin. Removing this layer might deprive the coin of its distinctiveness and authenticity, which are often more valued than mere visual appeal.

Consider the story of a fledgling collector who acquired what seemed to be a rare medieval coin. Believing that clearing the century-old tarnish would enhance its value, the individual used a commercial cleaner. The result was a coin stripped of its aged patina, revealing a too-bright underlayer that diminished its historical allure and, sadly, its market value. This scenario is a somber reminder that sometimes, the best preservation technique is a gentle, minimal approach—or even no intervention at all.

Another prevalent pitfall is the use of improper tools for cleaning. Everyday household items like paper towels or abrasive brushes can scratch a coin's delicate surface. Even chemicals that are seemingly harmless can have adverse reactions with the metals in a coin. For example, vinegar, often touted as a natural cleaning solution, can aggressively attack the surface of coins, especially copper-based ones, leading to pitting and etching that are irreversible.

Coins can also suffer from inappropriate storage methods. A common misconception is that regular contact with air and moisture is harmless. Yet, exposure to such elements is among the primary causes of corrosion and other forms of deterioration. As such, storing coins in suboptimal conditions like PVC holders, which can release harmful acids, or in environments prone to temperature fluctuations and humidity, can provoke chemical reactions which subtly degrade the coin's integrity over time.

Moreover, impatience in drying washed coins can lead to inadvertent damage. A collector once rinsed a coin under tap water and, in haste, used a hairdryer to speed up the drying process. The intense heat not only warped the delicate coin but also induced thermal shock, which resulted in fine cracks on its surface. The proper technique would have been air drying in a controlled

environment, where the coin could slowly return to its natural state without interference. An equally impactful error arises from the common lack of documentation or mismanagement of the chemical products used in cleaning. Each chemical interaction with a coin's surface can potentially alter its character. Without proper records, repeated applications or combinations of inappropriate chemicals can be catastrophic. In one instance, a well-intentioned collector mixed mild detergents to 'enhance' a cleaning solution, only to discover that the combination had caused a chemical reaction that darkened a silver coin irreversibly.

11. Documenting Your Collection

Cataloging and Record Keeping

The process of cataloging starts by establishing a reliable method to categorize your coins. Each entry in your collection's catalog should include basic yet crucial identifiers like the denomination, year of minting, mint mark, grade, and any distinctive features or variances. Additionally, Frank notes down any historical relevance or personal stories associated with his coins. This not only enriches his collection but also creates a narrative that breathes life into each metal round.

It's quite beneficial to adopt a digital approach. Utilizing software designed for coin collecting can streamline the cataloging process, ensuring entries are both thorough and uniform. Consider including high-quality images of each coin, capturing both obverse and reverse sides, which can be incredibly useful for insurance, sale, or simply sharing with fellow enthusiasts.

Building a Record-Keeping System

Effective record keeping transcends beyond mere cataloging. It encapsulates acquisition details—where, when, and at what cost each coin was obtained. For Frank, this is where his record-keeping intertwines with storytelling. Each coin is not just a transaction but a chapter of his adventure, capturing moments of haggling at flea markets or the anticipation of auctions.

In his records, Frank also includes details like restoration work if a coin required cleaning, conservation efforts, or professional grading services. Such records are invaluable, especially when preparing coins for sale or evaluation, providing potential buyers or appraisers with a clear, documented history of each piece.

Why Digital Tools Matter

While traditional pen-and-paper records have their charm and place, the digital age brings tools that significantly amplify your ability to manage your collection. Software solutions can offer functions like automated backups, cloud storage for remote access, and features that simplify generating reports or searching for specific coins.

Furthermore, integrating a digital toolset helps you stay updated with market values and trends. With connected applications, updates about fluctuations in coin prices can be directly fed into your records, allowing you to reassess your collection's worth in real-time—a crucial feature for serious collectors who view their assortment as an investment.

A Unified System

The ultimate goal is to have a unified system where cataloging and record keeping become seamless aspects of your collecting process. This system doesn't just safeguard your collection's historical and financial data; it enhances your engagement with the hobby. Each entry becomes a stroke in the larger canvas of your numismatic journey.

Consider also the community aspect. Sharing your catalog online with fellow collectors or contributing data to numismatic studies can elevate the whole field, providing insights and data points that were previously siloed in personal collections.

Overcoming Challenges

However, setting up and maintaining such a detailed system does have its hurdles. The initial setup can be time-consuming, especially if you are digitizing old records. There is also a learning curve with any new software, and the ongoing need to update records as your collection grows or changes.

Consistency is the remedy here. Regular intervals for updating records, perhaps aligning with new acquisitions or quarterly reviews, can keep the task manageable. Remember, this meticulous approach not only aids in understanding the legacy of each piece but proves indispensable in situations where proof of ownership or valuation is required.

The Lasting Benefit

What does Frank gain from his diligent practices, and how does this affect you as a collector? His stories, captured in the thorough records, have turned his collection into a narrated museum of his numismatic journey. For anyone, whether you're cataloging your first few coins or managing a vast, valuable collection, the principles remain the same. The integrity and value of your collection are greatly enhanced by the quality and reliability of your documentation.

SOFTWARE AND TOOLS FOR COIN DOCUMENTATION

The transition to digital tools for coin documentation offers more than just sleek interfaces—it brings a holistic change in how we access, analyze, and archive our collections. For instance, Margaret uses database software that not only records every detail of her coins—from origin, year, type, and condition—but also allows her to attach images and historical documents related to each piece. This feature turns her collection into a virtual museum, accessible from anywhere in the world.

Moreover, the real-time data analytics provided by some advanced platforms offer Margaret perspective on trends such as the fluctuation in market value of specific coins or noting which pieces in her collection have appreciated the most over time. These insights, powered by robust back-end algorithms, help her make informed decisions whether she's buying new pieces or considering offers on coins she might sell.

Customization to Collector's Needs

Software and tools for coin documentation come with varying levels of customization. From templates that mimic the classic coin collection books to user-generated fields that can be as

detailed as the collector desires, these tools can accommodate collections of any size or type—be it a modest assortment of circulated coins or a vast array of rare mint conditions.

Margaret, for example, tweaked her software to include fields specific to the tracing of the coin's provenance and any restoration work that has been done. Her system sends her reminders for potential resale opportunities, and alerts her to upcoming auctions that might interest her specific niche of medieval European coins.

Collaborative and Sharing Features

Modern software often includes options to share your collection online. This can be particularly useful for those who are part of coin clubs or online forums. Margaret, for example, frequently shares parts of her collection on online numismatic forums, contributing to discussions about rare finds or particular mint varieties. This ability to share and collaborate digitally not only enhances her reputation as a knowledgeable collector but also assists beginners in the community, who can learn from her well-documented examples.

Security and Backup

One crucial advantage that digitized documentation holds over traditional methods is security. High-end encryption and secure backups ensure that your data is protected against both physical and cyber threats. For Margaret, the peace of mind that comes from knowing her data is automatically backed up and stored securely in the cloud is invaluable. Should her physical records ever be compromised, her digital archive remains intact and recoverable.

Challenges and Considerations

Naturally, the shift to digital does not come without its challenges. The initial setup and migration of existing data into a new system can be a daunting task. Margaret spent several weekends transferring her handwritten logs into her chosen software, a meticulous process that required careful verification to ensure no detail was overlooked.

Additionally, the learning curve associated with new software can be steep, especially for those who are less digitally savvy. Margaret combated this by joining online workshops and watching tutorial videos related to her documentation software to speed up her mastery of the new tools.

Assessing Your Collection's Value

In the dynamic world of coin collecting, the act of appraising and estimating the value of your collection is not merely a numerical exercise but a story of context and perspective. Understanding the worth of your coin collection involves more than checking the year and mint mark—it's about comprehensively evaluating the narratives, the rarity, and the condition of your coins, all held against the ever-changing backdrop of the market.

Consider Samuel, an ardent numismatist, who decided that to truly appreciate the extent of his growing collection, he needed an in-depth evaluation, not just for insurance purposes but also to refine his collecting strategies. Samuel's story sheds light on the multifaceted approach required to accurately assess the value of a coin collection, a process that if done correctly, adds both confidence and depth to a collector's endeavor.

Historical and Market Context

Each coin in Samuel's collection is a snippet of history, its value intricately tied to that specific past. When assessing the value, the first layer of inquiry typically delves into the historical significance—was the coin minted during a notable short-lived reign, or does it come from a mythical hoard found in an ancient shipwreck? Such stories substantially augment a coin's value. However, historical context needs to be balanced with market dynamics. Samuel keeps a keen eye on market trends, often referring to auction results, dealer prices, and numismatic publications to understand how particular types of coins are valued in the current market. For Samuel, this isn't just research, it's a means to gauge how his collection may be positioned should he decide to sell or insure it.

Technical Evaluation

Crucial to assessing value is an accurate technical evaluation of each coin. This is where Samuel's meticulous documentation, recording every detail from date, mint mark, and notable blemishes to authentication papers, comes to life. But assessing isn't solely about logging details—it's about understanding their implications. The presence of a specific mint mark can transform a common coin into a rarity, a detail only found through diligent study.

Furthermore, Samuel invests in regular professional grading of his coins. Third-party grading services play a pivotal role in certifying the condition of a coin, categorizing it on a scale from Poor to Mint Condition. These certifications, while presenting an upfront cost, could significantly enhance the perceived value of the coins, making them more attractive to potential buyers or historians.

Comparative Analysis

Evaluating a coin's value often involves comparative analysis.

Samuel regularly attends coin shows, visits auctions, and partakes in online forums where he can compare his coins against similar ones in other collections. This hands-on approach notifies him if some of his coins are undervalued based on their physical condition or historical significance compared to their market price.

The Role of Rarity and Demand

Two pivotal factors that influence a coin's value are its rarity and demand. Samuel knows that a rare coin might attract higher values, but if there's low demand for that rarity, its market value might not reflect its uniqueness. He keeps an eye on collecting trends, understanding which erases of coins are gaining popularity, and which are fading out. This insight allows him to predict which pieces to acquire or let go of, optimizing his collection's market relevance and value.

Emotional Value Vs. Market Value

Beyond dollars and cents, there's an emotional value tied to Samuel's collection. Each coin narrates a personal journey—a flea market find that snowballed into a historic chase, or a gift from a fellow enthusiast that opened doors to a new numismatic chapter. While these stories may not translate directly into monetary value, they enrich his collection's worth in ways that only a true collector can appreciate.

However, Samuel is careful to distinguish between emotional value and market value. This awareness prevents him from overvaluing his collection based on personal attachment and allows him to remain objective about each piece's worth.

Regular Reappraisal

Given the fluid nature of the coin market, Samuel maintains a routine of reassessing his collection's value annually. This not only keeps him updated with the latest market conditions but also prepares him for unexpected opportunities to buy or sell. Moreover, it ensures that his insurance coverage is adequate and reflective of his collection's true value, safeguarding his investment against loss or damage.

12. THE COIN MARKET

UNDERSTANDING COIN VALUATION

To navigate such scenarios, begin by understanding the fundamental drivers of coin valuation: rarity, demand, and condition. Each of these factors plays a significant role in determining the value of a coin.

Rarity

Rarity is perhaps the most romanticized quality of a coin. It is often thought that the fewer the coins minted, the higher the potential for value. However, rarity alone isn't enough to elevate a coin's worth. For instance, many ancient coins, despite being few in number, may not command extraordinary prices because the demand isn't as high. Contrast this with the 1913 Liberty Head Nickel, of which only five exist, and where demand skyrockets due to its storied past and collector interest, driving its value into the millions.

Demand

Demand is influenced by several factors, with historical significance and collector interest at its core. Coins that feature pivotal moments in history or are part of a notable series tend to attract higher interest. Similarly, coins that complete a series or represent a missing puzzle piece in a themed collection can also see elevated demand. The 2008-W Silver Eagle with the Reverse of

2007 is a fascinating case; its value soared due to a mint error that intrigued collectors, making it a sought-after piece despite the relatively recent issue.

Condition

The condition of a coin is judged through a practice known as grading. The scale from Poor (PR) to Mint State (MS) and beyond into Proof (PF) ratings quantifies tiny differences that significantly impact a coin's appeal and thus its market value. A coin in a superior state of preservation without wear or damage can be valued exponentially higher than its lower-grade counterparts.

Understanding these complexities, seasoned collectors often turn to the historic price movement of similar coins, known as price performance, to aid their valuation process. By studying auction results and dealer pricing histories of coins with similar characteristics, collectors can form an informed estimate of a coin's current market value.

Additionally, tools and resources like the Red Book (Official Red Book: A Guide Book of United States Coins) provide yearly updates on coin values and are an indispensable tool for enthusiasts. Online resources, including auction house databases and numismatic marketplaces, also offer real-time data that can be crucial for making on-the-spot decisions.

As you grow in your numismatic journey, you'll likely develop a "gut feeling" for valuation, a synthesis of accumulated knowledge and experience. Remember the instance of the 1909-S VDB Lincoln Penny? A seasoned collector would likely assess its surface, verify its authenticity, and compare its market history before making an offer. This due diligence process, while rigorous, is immensely rewarding, turning each acquisition into a victory in its own right.

Moreover, market trends play a significant role in coin valuation. Economic factors, new discoveries, and shifting collector interests can all influence the market. For example, an increase in gold prices can directly impact the value of gold coins, while the discovery of a new cache of historically significant coins might temporarily decrease the value of similar items in the market.

In navigating these waters, networking with other collectors and joining numismatic communities can provide insights and firsthand experiences that are invaluable. Discussions at coin clubs, forums, and shows often reveal the nuances of the market that aren't captured in books or online.

MARKET TRENDS AND INFLUENCES

Economic Factors

The economy plays a fundamental role in shaping the numismatic market. During times of economic prosperity, collectors might feel more comfortable splurging on high-ticket items. Conversely, in downturns, the market might see an influx of coins as collectors sell off assets to free up cash. Precious metal prices also significantly affect coin values. For example, coins with a high gold or silver content might become more desirable as metal prices rise, as seen during the spikes in gold price in the early 21st century.

Historical Events

Significant events can also affect coin values. Commemorative coins related to major anniversaries or historical milestones often see increased interest around the event date. For instance, coins celebrating important battles or national heroes can gain in value during relevant centennial celebrations.

Technological Advancements

Advances in technology have allowed for better preservation, authentication, and grading of coins, thus influencing their market value. High-resolution imaging technology and sophisticated analysis techniques have made it easier for collectors to buy and sell coins with confidence, often without needing to handle the coins in person. This technological shift has helped globalize the collector's market, expanding the reach and impact of trends.

Changes in Collecting Trends

Collecting trends can shift subtly over time, guided by generational changes in tastes or sudden spikes in interest due to external influences like popular culture. The rise of thematic collecting, where collectors focus on a specific narrative such as maritime history or architectural motifs, has broadened the scope of what is considered valuable. Understanding these shifts can give a collector the edge, allowing them to anticipate and capitalize on emerging trends.

Influences from Key Players

The numismatic market is also swayed by the actions of key players—major collectors, influential dealers, and prominent auction houses. The disposal of a significant private collection, for example, can flood the market with rare pieces, temporarily affecting prices. Likewise, a high-profile auction that breaks price records for a particular coin can reset expectations and valuations across the board.

Take the case of the 1933 Saint-Gaudens Double Eagle, which fetched an astonishing sum at auction that set the numismatic community abuzz. Such events can catalyze interest not only in similar coins but also in the era or theme they represent, influencing market movements.

Influence of Global Events

Finally, global events such as political instability, changes in trade regulations, or international economic crises can also play a role. Collectors might find opportunities in markets that are newly opening up due to changes in political landscapes or be cautious about regions experiencing turbulence.

Navigating these trends requires a blend of keen observation, historical knowledge, and a bit of intuition. Engaging with other collectors through forums, clubs, and conventions can provide valuable insights and help you stay ahead of trends. Regularly reading trade publications and attending auctions can also offer a pulse on the market's heartbeat, revealing what is up-and-coming or fading into the background of the collector's world.

INVESTING IN COINS

Investing in coins is much like embarking on a treasure hunt where history, art, and finance intriguingly converge. For many, the allure of numismatics isn't just the beauty or the historical significance of the coins but also their potential to serve as robust financial investments that can weather turbulent economies.

Take the story of the 1794 Flowing Hair Silver Dollar, for instance. Recognized as one of the most valuable coins in the world, it epitomizes the quintessential investment-grade coin: rare, coveted, and steeped in rich history. Its journey from a mere dollar coin to a multi-million-dollar investment teaches a fundamental lesson on the lucrative possibilities that careful, knowledgeable investing in coins can offer.

Understanding Investment Grade Coins

The key to successful investing in the numismatic world hinges on identifying what makes a coin 'investment grade.' Typically, these coins have several attributes: rarity, demand, historical significance, and exceptional condition. For example, coins that were minted in limited numbers or have errors often carry a rarity that can significantly enhance their value.

However, it's not just about rarity. The coin's demand in the collector's market plays a crucial role. A rare coin might not attract high returns if there is no significant demand. Conversely, some relatively common coins might fetch handsome prices due to high collector interest, such as those associated with a particular historical epoch or coins discontinued from circulation, triggering nostalgia and demand.

The Role of Condition

The grade of the coin is paramount. This is where coin grading comes into play, an objective measure to ascertain the coin's physical condition. Coins graded in Mint State (MS) condition,

especially those close to perfect (MS-70), often command higher prices. The grading is so critical that even a single point difference can mean a drastic change in a coin's market value.

For investment purposes, professionally graded coins by reputable services like the PCGS (Professional Coin Grading Service) or NGC (Numismatic Guaranty Corporation) are preferred. Their encapsulation and certification provide assurance of the coin's authenticity and condition, making them more reliable for investment.

Historical Performance and Liquidity

Investing in coins also requires an appreciation of their historical price performances. Some coins might have shown steady appreciation over the decades, while others could be more volatile. The 1907 Saint-Gaudens Double Eagle, for instance, has consistently appreciated owing to its artistic design and gold content.

Liquidity is another critical factor. Some high-value coins, despite their worth and rarity, can be harder to sell due to their very niche demand. Therefore, understanding which coins are liquid and can easily be sold in the market can influence investment decisions. For instance, widely recognized coins like the American Gold Eagle or the Canadian Maple Leaf tend to be more liquid.

Diversification and Timing

Diversifying your coin investments can mitigate risks. This means not just investing in gold coins but also considering silver, platinum, or historically significant non-precious metal coins. Also, knowing when to buy or sell is crucial. The numismatic market has its cycles, often influenced by broader economic conditions or sector-specific trends.

Timing the market can be challenging, but keen observation of market trends and economic indicators can provide valuable insights. For instance, buying during a downturn when prices are typically lower and holding until the market strengthens can yield significant returns.

Inflation and Hedging Properties

Coins, especially those made from precious metals, often hold intrinsic value that can act as a hedge against inflation. During times of economic instability where traditional stocks and bonds might depreciate, gold and silver coins could retain value or even appreciate.

The Emotional and Educational Return

Beyond tangible financial gains, investing in coins offers intangible returns. The joy of owning a piece of history, the thrill of the hunt for rare pieces, and the intellectual satisfaction of researching and discovering the stories behind coins can provide immense personal satisfaction that isn't typically measured in monetary terms.

Long-Term Perspective

Approaching coin investment with a long-term perspective is advisable. While some might look for quick profits from buying and selling within short cycles, the most substantial gains typically come from holding onto select, high-quality coins over extended periods.

13. Rare Coins and Hidden Gems

IDENTIFYING RARE COINS

Rarity doesn't merely imply old or unusual. A coin's rarity is often tied to its mintage numbers, the survival rate of similar coins over time, and its condition. For instance, while millions of Lincoln pennies were minted in the early 20th century, those with specific mint marks or error variations—like the 1955 double die obverse—are exceedingly rare. This scarcity can transform an otherwise common coin into a collector's prize.

However, rarity also comes from less obvious places. Consider the context of a coin's creation. Coins minted during years of turmoil or rapid change, such as those struck during the short reigns of certain leaders or ephemeral government shifts, often did not survive in large numbers. These coins can become rare gems hidden in plain sight.

The Role of Provenance

The history of a coin's ownership, or its provenance, adds layers to its narrative that can be crucial in understanding its rarity and value. A coin from the collection of a renowned historical figure or one that was part of a famous hoard or discovery often carries more intrigue and potential value. Provenance can make an otherwise accessible coin unique because of its storied past.

Consider the 1933 Saint-Gaudens Double Eagle, a coin with such an intriguing provenance that it involves a presidential order that recalled gold coins from circulation and a handful that were stolen, only to resurface under mysterious circumstances decades later. Such stories not only make these coins rare but legendary.

Techniques for Identifying Rare Coins

Identifying rare coins is a skill sharpened by experience and education. First, familiarize yourself with the key characteristics that define different eras of coinage. Learn the hallmarks of major U.S. and world mints, understand the inscriptions and imagery typically used, and know how geopolitical changes affected coinage.

Another effective approach is learning to "read" a coin—much like a scholar reads an ancient manuscript. This involves more than recognizing the face value and date. It's about observing mint marks, understanding variations in design that may indicate a limited run, and recognizing errors that escaped mint quality control. Such errors can dramatically transform a common coin into a rarity.

Use tools like a strong magnifier or loupe to examine coins closely. Details invisible to the naked eye, such as slight variations in embossing or anomalies in mint marks, often distinguish a rare coin from its more commonplace counterparts.

Engaging with the Community

No collector is an island, and the wisdom of the numismatic community can be an invaluable resource in your quest for rare coins. Relationships with experienced collectors, dealers, and historians can provide insights and opportunities not available through solo efforts.

Participate actively in forums, attend coin shows, and engage with coin clubs. Occasionally, a story shared in casual conversation at these gatherings could lead you to a rare find or offer a new perspective on a piece in your collection. Listening to others' experiences and learning from their expertise can be just as important as any technical knowledge you acquire.

Evaluating a Coin's Authenticity and Condition

The ability to discern a coin's authenticity and assess its condition accurately is critical. The market unfortunately includes counterfeit coins and altered specimens designed to fool the unwary. Learning the subtleties that distinguish a genuine rare coin from a fake involves understanding the materials and minting techniques of the period in question.

Grading a coin's condition, from mint state to circulated grades, also affects its rarity and value. A coin in nearly pristine condition is significantly rarer than one showing signs of wear and age. This does not just apply to older coins; modern limited-issue coins in flawless condition can also be rare due this perfection.

Each rare coin you identify and add to your collection builds your narrative as a collector. Like the authors of the greatest stories, you weave together threads of history, art, and personal growth. The rare coins are your characters, each one playing a role in the story of your collection.

Imagine yourself now, years from now, sharing the story of how you came across your rarest find. Perhaps it's that 1916-D Mercury dime from the antique store, or something even more extraordinary. Each coin's journey to your collection is a testament to your skills and perseverance, showcasing both your dedication to preserving history and your ability to uncover hidden treasures.

THE MOST VALUABLE COINS IN HISTORY

Equally captivating is the tale of the Double Eagle, a $20 gold piece minted in 1933. Never officially released into circulation due to a change in currency laws during the Great Depression, most of the 1933 Double Eagles were melted down. However, a few specimens escaped this fate due to historical quirks and subterfuge, making their survival a story of almost cinematic intrigue. The few that remain are some of the most sought-after pieces by collectors worldwide, with a single coin reaching over $7.5 million at auction. Crossing the Atlantic brings us to the fabled British 1933 Penny. Unlike its American contemporary in terms of composition—humble bronze versus glamorous gold—this penny is rare due to its incredibly limited mintage. Only a handful of these pennies were struck, originally intended for ceremonial purposes as the United Kingdom, like the U.S., was also reconsidering its currency system at the height of the Great Depression. Owning one of these is a token of having conquered one of the peaks of British numismatics.

Traveling further back in time and yet a continent away, the allure of ancient numismatics is best illustrated by coins like the Athenian Owl Tetradrachm. Minted over 2,500 years ago, these silver coins depict the goddess Athena on one side and her sacred owl on the other, symbolizing wisdom and vigilance. Prized for their beautiful, classical artistry and relative rarity, these coins fetch hefty sums at auctions and are considered pinnacles of ancient coin collecting.

But what propels a coin to go beyond the ordinary, beyond even the extraordinary, to fetch astronomical values at auctions? Several factors play into this: the story of its origin, its rarity, the condition, and sometimes its previous owners. The coins that weave the most intriguing tales are often those that have passed through the hands of kings, emperors, or been at the heart of a notorious crime. For instance, the Umayyad Gold Dinar, dated 723 AD, tells a tale of ancient economic stability and artistry in the Islamic world. Minted in a gold-rich land, this coin is not just a piece of high purity gold; it represents one of the earliest uses of Islamic text on coinage, attaching to it both cultural significance and rarity. In 2011, one such dinar fetched over $6 million,

highlighting the robust market for Islamic historical artifacts. Within these stories, there lies not just a lesson on the rarity and historical significance but also the importance of preservation. Each coin, by virtue of surviving, sometimes against unlikely odds, teaches about the conditions that preserved it—whether kept in royal treasuries, buried as part of a Viking hoard, or tucked away in private collections throughout turbulent times. For a collector, understanding the market dynamics that propel such coins to their valuations is crucial. It's not merely about the aesthetics, metal content, or age. It's about the narrative each coin carries and how it resonates with collectors. The strategy, then, involves not just a pursuit of these coins but a deep dive into their stories, understanding why each piece was treasured by those who held it before—a quest that can be as rewarding financially as it is intellectually. However, the thrill of chasing the most valuable coins should always be tempered with a reminder about the authenticity and legal provenance of such pieces. High-value coins are particularly subject to counterfeiting and require verification by reputable experts. Additionally, understanding the legal framework regarding the ownership, trade, and transport of ancient and valuable coins ensures that your collecting remains not just enjoyable but also ethically and legally sound.

How to Spot Hidden Gems

To identify hidden gems, your first tool is your observational skill. Enthusiasts must learn to scrutinize coins critically. Start by examining the usual suspects: mint marks and dates. Sometimes, the rarity is concealed in plain sight—a misprinted date, a barely noticeable mintmark, or an odd coloration that hints at a distinctive composition of metals. Further, understanding errors and variations that occurred during minting processes can transform an ordinary coin scouting session into a treasure hunt. For instance, double dies and off-center strikes are not just minting mistakes; they often carry high value for collectors. These anomalies can make even common-date coins highly desirable.

Knowing Historical Contexts

Knowledge of historical contexts significantly enhances your chances of finding hidden gems. Every collector should immerse themselves in the stories behind mintage years, especially those that coincide with significant events—wars, economic depressions, or changes in metal compositions. Such times often led to unique or limited issues of coins, which today are rare and valuable. For instance, coins struck during the brief reigns of lesser-known rulers, or pieces minted during transitional periods in governments, are often overlooked yet hold considerable value due to their scarcity and historical significance. Having a backstory to the tune of political upheavals or economic crises can significantly increase a coin's value.

Exploring Beyond the Usual Places

While many collectors frequent auctions and dealers, hidden gems are often found where least expected. Thrift stores, estate sales, and even online marketplaces can occasionally surprise you with rare finds. Another often-overlooked venue is old collections passed down through families—coins that were once saved as souvenirs or investments and forgotten over time. It's also worth reaching out to non-collectors who might possess valuable coins without realizing their worth. Engaging with history enthusiasts, antique lovers, and even metal detectorists can lead to fruitful collaborations. Sometimes, the detachment from the numismatic world means they undervalue or overlook the treasures they hold.

Utilizing Technology Effectively

In the digital age, collectors have unprecedented access to resources that can aid in identifying hidden gems. Online forums, auction platforms, and coin databases offer wealth of information and the opportunity to compare notes with other collectors worldwide. Furthermore, apps and websites that catalog coin errors, rare mintage characteristics, and valuation estimations provide indispensable tools at your fingertips. They allow collectors to quickly cross-reference coins against databases of known rarities and pricing guides, making the identification of potential hidden gems more efficient.

The Importance of Networking

While numismatics can sometimes be a solitary hobby, the most successful collectors know the value of community. Networking with other collectors and industry professionals can provide insider knowledge and tips on where to find underappreciated coins. Joining numismatic clubs and attending coin shows not only aids in expanding your knowledge and collection but also in building relationships that might one day lead to a tip-off about a rare coin quietly sitting in an overlooked collection. These relationships can become as valuable as the coins themselves, offering pathways to opportunities otherwise inaccessible.

Evaluating Potential Finds

Whenever you stumble upon a potential hidden gem, conducting a detailed assessment is crucial. Verify its authenticity and condition, ideally with the help of professional grading services. Understanding the grading standards and being able to preliminarily judge the grade of a coin yourself can save you from costly mistakes. Remember, even a rare coin can lose significant value if it has been improperly cleaned or handled. Finally, remember that finding hidden gems is not an everyday occurrence—it's the long game that yields results. Patience, persistence, and continuous learning are your best tools. Each coin examined, whether it turns out to be a hidden gem or not, adds to your experience and sharpens your eye for detail.

14. Selling Coins

Preparing Coins for Sale

Begin by thoroughly examining each coin you intend to sell. Assessing your coins involves more than simply looking over them; it's about understanding their places in the spectrum of collectability and market demand. Recall the time you discovered a rare 1913 Liberty Head nickel or that Morgan dollar with the misprinted mint mark. Place yourself in the shoes of a potential buyer—who will find intrigue and value not just in the coin itself but in its story and condition.

The Art of Presentation

First impressions count immensely. Each coin should be cleaned—not in the traditional sense of removing patina, which can diminish value—but rather, ensuring that any loose dirt or debris is carefully removed without damaging the coin's surface. Remember, aggressive cleaning can often backfire, turning what was once a prized asset into a sadly diminished token.

Then, consider the coin's packaging. Proper holders or cases not only protect coins from physical damage but also subtly enhance their appearance and make handling easier for potential buyers. Use high-quality flips, capsules, or presentation cases depending on the coin's value and type. This will demonstrate your care and professionalism, qualities that reassure buyers of the credibility and quality of their potential purchase.

Recounting the Provenance

Each coin in your collection carries a narrative—where it has been, how it entered your collection, and any historical significance it may possess. Providing a documented provenance can add layers of value to a coin. It proves authenticity, places the coin in a historical context, and can be a compelling story that captivates the right buyer.

Prepare a succinct but engaging history of each coin. If a coin was part of a famous collection or had been minted under extraordinary circumstances, these are details worth mentioning. Including certificates of authenticity or grading reports from recognized bodies will further solidify the trust between you and the buyer.

Photography: A Picture Speaks Volumes

In the age of digital sales and online auctions, photography will often be a prospective buyer's first real engagement with your coins. Invest in good-quality, clear, and detailed photos. Capture multiple angles and include close-ups of important features, such as mint marks, distinctive details, and any flaws. Good lighting and a neutral background will focus attention on the coin itself rather than on distractions in its vicinity.

Setting the Stage: Information and Descriptions

When listing coins for sale, whether in auction catalogs or online platforms, the description of each

piece can clinch a deal. Write clear, accurate, and detailed descriptions that are not only factual but also weave in the allure and historical importance of the coin.

Highlight key attributes like the year of minting, the mint mark, the coin's grade, and any unusual features or rare errors. Be transparent about any defects or wear as this honesty can build trust and help avoid disputes later.

Engagement and Communication

Once your coins are out there, either in the physical realm of a coin show or listed online, your role shifts to that of a communicator. Engage with potential buyers by answering queries, providing more information requested, and sharing insights into why each coin is special. This personal touch can transform a routine sale into an enriching experience for both buyer and seller.

Anticipations of a Sale

Finally, as queries come in and offers are made, keep your communication professional and your negotiations fair. Remember, today's buyer could become a returning customer or even refer others to your collection.

Choosing the Right Selling Platform

Exploring Traditional Auction Houses

Consider the traditional auction house, a venue steeped in history and filled with enthusiastic collectors who can appreciate the rarity and value of high-quality coins. These institutions are not just selling points; they are gatherings where history buffs and enthusiasts meet. The physical display and the tactile experience of evaluating coins can significantly enhance their allure.

Storytelling plays a crucial role here. An auctioneer doesn't merely list qualities and defects but weaves a narrative around each coin, bringing to life its historical significance and rare attributes. This narrative often resonates with collectors who value the story as much as the coin.

Venturing Into Online Auctions

Then there's the digital frontier: online auction platforms. Here, the reach is global, and the potential buyer base is vast. Coins that might attract modest interest in a local setting could become stars in this larger arena. The key to success in online auctions lies in presenting your coins impeccably. High-resolution photography and detailed, compelling descriptions are paramount in capturing the attention of distant buyers who cannot physically interact with the coins.

Online platforms also demand a different kind of vigilance. The transparency of transaction histories, seller ratings, and buyer feedback forms a backdrop against which every sale takes place. Maintaining a strong seller reputation is as crucial here as the quality of the coins being sold.

Embracing Numismatic Trade Shows

Another vital selling arena is the numismatic trade show. These events are melting pots of opportunity, drawing collectors and dealers from various backgrounds. Trade shows allow for face-to-face interactions, providing a tactile experience that online platforms cannot replicate. Here, your conversational skills and your ability to convey the nuanced histories and details of your coins can directly influence a sale.

Preparation for a trade show involves not just knowing about your coins but also understanding the trends and interests that drive the current market. Being attuned to these nuances can help in setting prices that are competitive yet fair, striking a balance between profit and marketability.

Choosing Specialty Dealers or Shops

For some collectors, selling through specialty dealers or local coin shops may be the preferred route. This option combines a personal approach with professional ease. Specialty dealers often have established client networks looking for specific types of coins. If your collection matches their needs, these dealers can facilitate sales that are both swift and satisfying.

Working with dealers requires trust and transparency. Establishing a relationship with reputable dealers over the years can ease the process significantly. These professionals not only provide access to eager buyers but also offer valuable pricing insights and market trends that are hard to gauge from the outside.

Harnessing the Power of Online Forums and Social Media

In our interconnected digital age, online forums and social media platforms have emerged as vibrant marketplaces for coins. Platforms like Instagram or Facebook, and forums dedicated to numismatics, provide informal yet effective venues for selling coins. They combine the wide reach of digital marketplaces with the communal feel of collector clubs.

Selling in these digital communities requires adaptability. The informal nature of these platforms allows for more personal interaction with potential buyers, which can be leveraged to build long-term collecting relationships. Moreover, using these platforms effectively requires staying active and engaged with the community, consistently sharing updates and insights about your collection before making a sale.

Choosing the right platform to sell your coins is a nuanced decision, influenced by the nature of your collection, your personal selling style, and the level of engagement you wish to have with potential buyers. Whether you choose the grand stage of an auction house, the global reach of online platforms, the dynamic environment of trade shows, the specialized attention of dealers, or the community-oriented world of social media, each platform offers unique advantages and challenges.

Negotiating and Closing Sales

The journey toward closing a successful sale often begins long before actual price negotiations. It starts with setting a strategic price, which doesn't merely reflect the value of the coin but also considers the psychology of pricing. Coins are not merely traded commodities; they are pieces of history, art, and passion. Each coin has its story, and the price should suggest its value without deterring potential buyers.

Imagine you're setting a price for a rare 19th-century coin. The temptation might be to set a high starting price due to its rarity. However, pricing must be informed by comparable sales and current market interest, which provides legitimate backing for your figures. This does not only ease the negotiation process but also instills confidence in potential buyers that the price is fair and researched.

Communication: The Art of Listening

Entering negotiations, the key weapon in your arsenal should be not your prowess in speaking, but in listening. Effective negotiators are adept at reading between the lines—understanding buyer's pauses, hesitations, and the unsaid words. Listening extends beyond words; it's about noticing enthusiasm in a buyer's tone or the concern in their furrowed brows when discussing a coin's condition.

For example, if a buyer hesitates on price but shows keen interest in the specifics of a coin's history, it reveals that their reservation might be more about value assurance than expense itself. Here, reinforcing the coin's unique attributes and rare features or providing additional documentation might ease their concerns more effectively than lowering the price.

Adaptive Negotiating Tactics

Flexibility is a crucial element during negotiations. Each buyer is unique, and each coin may hold different significance to different people. Some buyers are swayed by the historical significance of a coin, while others might value its mint condition more. Tailoring your approach based on the buyer's interests can help in steering the negotiation to a close that satisfies all parties.

Suppose a buyer is interested in the potential future value of a coin. Discussing past market trends, showing projections, and even sharing stories of similar coins that had appreciated over time can be persuasive. This approach not only helps in closing the sale but also assists the buyer in appreciating the purchase, viewing it as an investment rather than an expense.

Honesty as the Best Policy

Throughout your interactions, maintain an honest portrayal of each coin's condition and history. Trust is a crucial component of any negotiation. Once broken, it's challenging to regain and can ultimately disrupt a potential sale. If there are any flaws or peculiarities in a coin, disclosing them

upfront will reinforce your integrity as a seller and establish a trustworthy foundation for negotiations.

Say there's a slight scratch on a coin you're selling. Mention it before the buyer discovers it. Often, buyers can accept flaws if they are not caught by surprise. This transparency can lead to a more straightforward negotiation process and can even foster repeat business, with buyers more likely to return to a seller they trust.

The Closing: Sealing the Deal

As negotiations draw to a close, clarity in the final terms is imperative. Ensure that the agreed price, payment terms, and any guarantees or return policies are clearly understood by both parties. This might include issuing a formal invoice detailing the coin, the final agreed price, and other purchase conditions.

The moment of closing is also an opportunity to solidify a relationship with the buyer. A satisfied buyer not only brings repeat business but can also become an advocate for your collections through referrals and positive word-of-mouth. A congenial farewell message, a handshake, or even a follow-up message ensuring their satisfaction with the purchase can leave a lasting positive impression.

Lastly, remember that patience plays a significant role in achieving favorable sales outcomes. Sometimes, not all negotiations end in immediate sales, and that's okay. Some buyers need time to think over the deal, consult, or arrange funds. Keeping the communication lines open for future opportunities can turn a momentary no into a future yes.

PART VI: THE COLLECTOR'S COMMUNITY
15. JOINING THE NUMISMATIC COMMUNITY

LOCAL AND NATIONAL COIN CLUBS

Local coin clubs are often the grassroots of numismatic exploration. Joining these groups provides a front-row seat to learning through regular meetings, lectures, and hands-on sessions with seasoned collectors. These clubs cater to both novices eager to learn the ropes and veterans polishing their expertise. For example, imagine a club meeting in a small community hall, where a recent find—a rare 19th-century silver dollar—is passed around, allowing members to observe its details, discuss its history, and even explore its market value through lively, informed debate. These meetings are not just about showing off recent acquisitions; they provide a structured way to gain practical knowledge. From learning how to grade coins accurately to understanding market dynamics, the discussions you engage in can drastically enhance your collecting skills. Moreover, guest speakers, often experts in the field, are frequently invited to share their knowledge on a variety of topics, from historical significance of coins to tips on safeguarding your collection against common pitfalls such as counterfeits and scams.

National coin clubs, on the other hand, offer a broader canvas, connecting you with trends and movements at a national and international level. Membership in such clubs often includes subscriptions to esteemed numismatic publications, access to exclusive online resources, and invitations to national and international coin shows and fairs. These clubs play a pivotal role during major numismatic events, where collectors from various corners of the world converge. Here, amidst the larger network, your scope for interaction and learning expands exponentially. For instance, take the annual conference of a national coin collectors' society. Here, amidst workshops and seminars, auctions and dealer booths, collectors gain invaluable exposure to a wide range of coins from around the globe, along with insights into global market trends and networking opportunities that are hard to come by in local club settings. These experiences not only bolster your knowledge and collection but also embed a deeper sense of connection and belonging within the numismatic community.

Beyond learning and trading, coin clubs are instrumental in advocating for the collectors' interests. They serve as your voice in larger debates concerning coin collecting, from legislative changes to public awareness. The collective effort of club members can lead to more structured and favorable policies that benefit the community at large. Engaging in these advocacy efforts can also elevate your status from a passive collector to an active participant in shaping the future of numismatics. Moreover, the friendships and partnerships that form within these clubs often last a lifetime.

Shared interests and regular interactions pave the way for deep relationships built on mutual respect and a shared passion. These relationships can be incredibly supportive as you navigate through your collecting journey. Whether it's advice on a potential purchase or help recovering from a bad trade, the community stands with you, providing moral and practical support.

In fostering these relationships, many collectors find that their involvement in coin clubs reinvigorates their passion for the hobby. Each meeting, each trade, and each discussion adds a layer of enjoyment and satisfaction, making coin collecting not just a hobby but a part of their identity. This emotional gratification is what many collectors cite as the most cherished aspect of being part of a coin club.

BENEFITS OF MEMBERSHIP

Access to Expert Knowledge

In every coin collector's journey, there often comes a moment of doubt—a crossroad where the decision to buy, sell, or hold could change the destiny of a collection. Members of coin clubs enjoy privileged access to a wealth of numismatic knowledge through their peers and scheduled presentations. Much like in academic circles where scholars share groundbreaking research, numismatic clubs host talks and workshops conducted by experts whose insights can illuminate the most labyrinthine aspects of coin collecting.

Exclusive Resources

Membership in a coin club often comes with access to a treasure trove of resources often unreachable to the general public. Libraries of specialized literature, rare auction catalogs, and archived issues of prestigious numismatic journals are just a few examples. For instance, consider the value of being able to peruse through a vintage auction catalog ahead of a major bidding war—such a resource could very well tip the scales in your favor, helping you secure a win that others might miss.

Networking Opportunities

The dynamics of coin collecting are heavily influenced by relationships—knowing the right people can open doors that are otherwise closed. Coin clubs serve as a crucial nexus for formative connections. At club meetings, shows, or lectures, you can meet a variety of individuals, from those who have just begun their collecting journey to the venerable experts who have seen their collections become legacies. Each person you meet could be the source of a new learning experience or the collaborator you need to acquire or dispose of a pivotal piece in your collection.

Buying and Selling Advantages

Members of well-established coin clubs often enjoy perks such as member-only auctions, trading

sessions, and group discounts at major numismatic events. These platforms offer avenues to buy or sell coins in a trusted community where the authenticity and value of coins are less likely to be misrepresented. Moreover, these settings foster a fairer negotiation environment, cultivated through mutual respect and shared ethical standards, which are often endorsed by the club.

Educational Growth

Most collectors don't just collect coins; they collect the stories, the historical significance, and the rich knowledge that coins encapsulate. Numismatic clubs often sponsor classes, seminars, and even field trips, all designed to deepen understanding of various aspects of coin collecting. Whether it's mastering the grading of coins or understanding the historical contexts that influence numismatic value, educational growth is a significant benefit of club membership.

Emotional and Social Support

Coin collecting, while rewarding, can sometimes be a solitary pursuit fraught with frustrations and setbacks. The social interactions facilitated by club memberships can mitigate feelings of isolation. Clubs create a community of support where victories are celebrated, losses are commiserated, and challenges are collaboratively tackled. The psychological boost from being part of a supportive network should not be underestimated. It not only revives one's passion for the hobby but also promotes a healthier approach to collecting.

Advocacy and Representation

In a broader sense, coin clubs often take on roles that transcend individual benefits—they advocate for numismatics as a whole. This can mean lobbying against restrictive trade laws, promoting the educational value of collecting, or even engaging with the media to boost public interest in coins. Such endeavors not only benefit individual collectors but also help in preserving and advancing the hobby for future generations.

Legacy Building

Lastly, joining a coin club can be an essential step in legacy building—not just in terms of amassing a valuable collection, but also in contributing to the continuity and evolution of the club. Many clubs keep detailed archives and honor long-standing members, offering a kind of immortality within the community. As you contribute to the club—be it through sharing knowledge, serving in leadership positions, or promoting numismatic education—you weave your story into the larger tapestry of the club's history.

PARTICIPATING IN COIN SHOWS AND CONFERENCES

Each coin show and conference is a unique opportunity to deepen one's knowledge. Picture a series of expert-led seminars taking place alongside the main event, covering a range of topics from the intricacies of ancient coinage to the latest trends in digital numismatics. As a participant, you find yourself in a room, notebook at the ready, diving deep into the nuances of coin grading techniques demonstrated by a seasoned grader. It's almost like a master class where the collective wisdom of the numismatic community is passed down and debated.

The Marketplace

Central to any coin show is the marketplace. Envision rows upon rows of booths, each a mini-museum showcasing arrays of coins, each with a story to tell. Here, interactions aren't simply transactional; they're educational. Engaging with dealers and fellow collectors, you might find yourself holding a rare coin from the Byzantine era, learning about its history directly from a dealer whose passion for ancient coins is as boundless as your curiosity.

Navigating through these marketplaces offers a practical education in negotiation and valuation not found in books. The hands-on experience of examining coins, discussing their attributes, and negotiating prices is invaluable, providing insights into the real-world dynamics of the numismatic market that are far richer and more nuanced than what theoretical knowledge alone can offer.

Networking and Community Building

Coin shows and conferences serve as vital networking hubs. Whether you're a novice collector or a seasoned enthusiast, the connections you make here can lead to lifelong friendships and mentorships. Imagine striking up a conversation with a fellow collector over a display of medieval coins, only to discover that they frequent the same obscure online forums you do, or they offer insights into a collection niche you've been curious about.

For many, these interactions evolve into collaborations: joint ventures in acquiring or selling coins, sharing rare finds, or co-authoring articles for numismatic publications. The sense of community is palpable, as these events are often the catalysts for the formation of regional or specialty-based groups that continue to interact long after the actual event has concluded.

Inspirational Success Stories

Within the bustling atmosphere of a coin show or conference, inspiration is never in short supply. Here, you might encounter the celebrated collectors whose legendary finds were once your own read-from-afar tales in numismatic newsletters and magazines. Their success stories, shared during keynote speeches or casual meet-ups, act not just as a motivation but also as a beacon guiding newer collectors towards what is possible in the world of numismatics.

Participation Beyond Attendance

While attending these events provides numerous benefits, active participation can enhance the experience exponentially. Consider presenting a paper, conducting a workshop, or even setting up a booth. Through these activities, you engage with the hobby from a new vantage point—one where you contribute to the knowledge pool. This leadership role can elevate your standing in the community, opening doors to further opportunities for growth and recognition.

Challenges and Opportunities

Participating in coin shows and conferences does pose certain challenges—the costs of travel and accommodation, the intimidation of competing with more seasoned collectors, the sensory overload of immense displays. Yet, overcoming these challenges is part of the journey. Each hurdle crossed builds confidence and adds layers of experience to your collecting saga.

Additionally, for those unable to travel, many events now offer virtual attendance options, with live-streamed sessions and digital exhibitions that allow remote participation. These innovations in event format expand access, ensuring that more collectors can reap the benefits of these gatherings, regardless of geographical limitations.

16. Resources for Collectors

Essential Books and Magazines

Navigating through Numismatic Literature

Begin with the classics, such as "A Guide Book of United States Coins" by R.S. Yeoman. Affectionately known as the "Red Book" within the collecting community, this guide has been an indispensable annual publication since 1946. It doesn't simply list coins and their values; it educates its readers with rich narratives about each coin's origin, historical context, and production details. The Red Book exemplifies how essential a good reference book is, not just for pricing, but for understanding the fuller narrative of your collection.

Then, there's "The Standard Catalog of World Coins" by Chester Krause and Clifford Mishler. This series offers a comprehensive look at coins from every corner of the globe, with volumes dedicated to specific centuries. It allows collectors to dive deeply into the world market, where they can learn about obscure and fascinating coins they might never encounter otherwise. Each entry is meticulously detailed, providing clarity on issues like year, mint marks, variations, and estimated values based on condition.

The Role of Magazines in Coin Collecting

Magazines like "Coin World" and "Numismatic News" serve as the chroniclers of the coin collecting realm. They are not just publications; they are ongoing dialogues about the state of numismatics. Weekly or monthly issues bring the latest news, auction results, and developments directly to your doorstep. Articles might cover everything from the discovery of rare coins to legislative changes affecting collectors. These magazines foster a sense of community among collectors, offering a platform for sharing successes, challenges, and stories.

"Coin World," for instance, isn't just read for pleasure. It's a tool. Suppose there's a sudden spike in the value of 19th-century Russian coins. Regular readers of "Coin World" would likely be among the first to know, armed with this knowledge, they can make informed decisions about when to sell or buy.

Engaging with Specialized Publications

For those whose collecting tastes are more specialized, there are publications like "The Celator," which specifically focuses on ancient coins. Here, you can immerse yourself in the numismatic aspects of history that most textbooks only gloss over. Imagine reading an enticing article about Roman denarii, then realizing the coin from your collection is one mentioned in a historical battle's context. "The Celator" not only enriches your understanding of your coins but also connects you to the ancient world in a tangible way.

Using Literature to Enhance Collection Strategies

Effective coin collecting is not merely about acquiring pieces to add to your collection. It's about understanding what you collect and why. Publications can help shape your collecting strategy, guiding you towards making acquisitions that are not just valuable, but meaningful too. Perhaps a book highlights an underrated mint or a magazine article discusses emerging trends, like the rising interest in exonumia or tokens. Such insights can help pivot your collecting journey towards niches that may offer greater satisfaction or investment potential.

Imagine reading an in-depth profile of a famed collector in "The Numismatist," published by the American Numismatic Association. Their journey might inspire you to pursue a new collecting path or adopt a new strategy that makes your hobby even more rewarding. Perhaps their approach to thematic collecting - say, gathering coins related only to significant historical events - sparks an idea for your own collection.

Incorporating essential books and magazines into your numismatic endeavors is akin to building a bridge between your current knowledge and the vast experiences of those who have tread the path before you. As you turn each page, whether it be of a hefty catalog or a new issue of a magazine, you're not just reading; you're engaging in a conversation with the past and preparing for the future of your collection.

ONLINE FORUMS AND WEBSITES

Websites like eBay and Heritage Auctions have become the beating heart of the coin collecting marketplace. Here, collectors can participate in auctions without leaving their homes, bidding on coins from around the world. It's thrilling to engage in a bidding war, feeling the adrenaline rush as you compete for a rare find. Yet, the true value of these websites goes beyond their function as auction houses. They are educational tools, providing detailed photographs and descriptions that help collectors learn what makes each coin unique and how its value is determined.

Online sales platforms also offer a real-time look at how the market values different pieces. Observing the fluctuations of coin prices and noting the kinds of pieces that attract more interest can be incredibly insightful. This data, when parsed with a discerning eye, helps collectors not only make informed purchasing decisions but also understand broader market trends.

The Community in Conversation

Forums such as CoinTalk and the Collectors Universe message boards are the digital equivalents of coin clubs. Here, stories are shared, questions are posed and answered, and friendships are formed over shared interests. These platforms offer a myriad of viewpoints on issues like coin grading controversies or the ethics of coin cleaning. For a collector, engaging in these discussions

can be as enriching as any textbook because they offer practical, peer-reviewed advice. A new collector might post images of a recently inherited coin collection, seeking advice on identification and appraisal. Within minutes, responses from around the world begin to pour in. Some might offer insights into the coin's historical context, while others might advise on preservation techniques or suggest potential buyers for duplicates. This immediate feedback, sourced from the collective wisdom of the community, is invaluable.

Specialized Knowledge Portals

Beyond auctions and forums, there are websites dedicated to specific aspects of numismatics. For example, the Professional Coin Grading Service (PCGS) offers a wealth of resources including a comprehensive coin database, articles written by experts, and a photograde service that helps collectors approximate the grades of their coins by comparing them with high-quality images.

These specialized sites often host articles that delve deeply into niche topics — discussing the peculiarities of a particular minting process or the history of a certain coin series. Such detailed analyses can illuminate aspects of coins that might not be visible to the naked eye. Imagine discovering that the slight variation in the lettering of a coin could signify a rare minting error, turning a seemingly common coin into a collector's treasure.

Bridging Past and Present

Historical information is crucial in numismatics. Websites like the American Numismatic Association (ANA) not only connect users to current events and news but also to the rich history of coin collecting. Their online archives, accessible to members, can transport one back to the days when ancient coins were the newest form of currency, offering insights that help collectors appreciate the pieces in their collections as artifacts of human history.

Additionally, these sites promote ongoing education by hosting webinars and online courses on topics as wide-ranging as ancient Greek numismatics and modern coin grading techniques. For someone whose collecting journey is intertwined with a love for history, such resources are as thrilling as unearthing a buried treasure.

The value of online forums and websites to a coin collector cannot be overstated. They are more than just conveniences; they are transformative tools that democratize information, making the numismatic community more accessible and informed. Each click brings opportunities for acquisition, each post offers new knowledge, and every connection made ties together the past and present of this fascinating pursuit.

COIN COLLECTING APPS

One such transformative tool is an app designed to catalog and organize coin collections. No longer does our collector need to maintain voluminous binders or files; everything from acquisition details to sales records can be meticulously managed in a convenient digital format. Imagine an app that allows you to photograph your coin, automatically recognizes it, and then adds all known details about it from public records and databases. Suddenly, he is spending less time managing his collection and more time enjoying it.

Connecting with a Global Network

Apps also enable connections that transcend borders. Through integrated social features, collectors can share pieces of their collection with others, receive feedback, and even get advice from fellow enthusiasts across the globe. For instance, if our collector acquires a rare foreign coin, he can quickly get insights into its background and potential value from international experts, all within the app.

Moreover, many coin apps feature built-in marketplaces or links to auctions, which means collectors can buy or sell coins with ease. Our collector, who perhaps was initially reluctant to part with any piece, might find the convenience enticing enough to start trading, thus refreshing his collection and pursuing new numismatic interests.

Access to Information and Education

One revolution brought by these apps is the democratization of information. Previously, a collector might need an array of books or access to a good library to find detailed information about specific coins. Now, apps bring this information directly to their fingertips. With features like interactive directories, glossaries, and even virtual tours through coin history, learning becomes an integrated part of the collecting experience.

Consider, too, the potential for augmented reality (AR) in these apps, which could allow a collector to view a 3D image of a coin, possibly even observing features that are not discernible to the naked eye. This can be particularly enlightening for educational purposes or for preparing for exhibitions and sales, where understanding and presenting every detail of a coin can significantly enhance its value.

Tracking and Alerts

Apps also offer practical utilities such or price tracking and alerts. Our collector might be interested in the fluctuating values of gold coins. Through his app, he sets up alerts that notify him when the market price reaches his desired point. Such features not only assist in managing the financial aspects of coin collecting but they also help in making informed decisions about when to buy or sell, based on real-time data.

Personalization and Security

Modern coin collecting apps often include high levels of personalization and security. From data backups to encryption, these apps ensure that the detailed records of a collector's assets are secure yet accessible across multiple devices. Personalization features allow the interface, alerts, and data management systems to be tailored to the unique preferences of the user, making each app feel like a custom-designed tool for their specific collecting style.

Our skeptical collector, having integrated this technology into his daily practice, finds that these apps do not replace the tactile joy of handling coins or the pleasure of a face-to-face swap. Instead, they enhance these experiences. He discovers that instead of diminishing his passion, technology has expanded the horizons of his hobby, connected him with a community of like-minded enthusiasts, and provided tools that make every aspect of collecting more enjoyable and fruitful.

17. Tips for Lifelong Collecting

Continuing Education for Collectors

The numismatic world is ever-evolving, not stagnant. New discoveries about old coins often surface, altering values and desirability. Similarly, technological advancements continually reshape how we collect, from the tools we use to identify and grade coins to how we connect with other collectors globally. To keep pace, a collector must engage in continuous education, staying abreast of market dynamics, emerging trends, and scholarly research.

Taking courses offered by numismatic societies, attending lectures, and participating in workshops can transform a hobbyist into a sage collector. For instance, the American Numismatic Association (ANA) provides a series of educational programs and seminars that delve into various aspects of numismatics, from the very basic to the highly specialized. These learning opportunities not only expand your knowledge but also enable you to make informed decisions, thus protecting and enhancing your investments.

The Role of Digital Platforms in Learning

In our digital age, the landscape of learning has broadened significantly. Online forums, webinars, and virtual conferences have become invaluable resources for collectors who might not have easy access to physical events or societies. Websites dedicated to numismatics offer a wealth of information, including detailed articles, video tutorials, and interactive platforms where collectors can ask questions and share insights.

Moreover, online platforms often host virtual tours of collections and museums, offering a perspective that many collectors would never be able to experience otherwise. Such digital explorations can be particularly enlightening, revealing the minutiae of coin features and historical contexts which are often difficult to grasp through images alone.

Learning Through Teaching

One of the most effective methods to deepen one's knowledge is to teach it. Sharing your expertise with others not only reinforces your own understanding but also highlights areas that may require further study. Whether through presenting at club meetings, writing articles for numismatic publications, or conducting informal sessions at local schools or libraries, teaching is a rewarding way to engage with the material.

Imagine leading a session on the evolution of coinage in the Roman Empire, discussing not just the coins themselves but the economic, political, and societal shifts they represent. Such interactions not only enhance your reputation as a knowledgeable collector but also contribute to the growth of the numismatic community by inspiring and educating others.

Personal Research Projects

Embarking on a personal research project can be one of the most rewarding aspects of continuing education in numismatics. This might involve studying the coins of a particular era, tracing the history of certain mint marks, or even discovering the life stories behind notable collectors and numismatists. The findings not only expand your knowledge but also add immense personal value to your collection.

Consider, for instance, focusing on the intricate details of pre-Confederation Canadian coins. By documenting your findings, perhaps even publishing them or submitting them to a numismatic journal, you contribute to the collective knowledge pool while immensely enriching your own collecting experience.

Staying Curious and Involved

Ultimately, the path to lifelong learning in coin collecting is paved with curiosity and involvement. Attending coin shows, engaging with other collectors, and keeping the zest for discovery alive are what make numismatics endlessly fascinating. By embracing a mindset where education is seen not as a requirement but as an ongoing pleasure, your journey as a collector will be rich with knowledge and enjoyment.

STAYING PASSIONATE AND INFORMED

To keep the passion alive, one effective approach is to delve into the histories and stories behind the coins you collect. Consider a coin from the Byzantine era: beyond its age and rarity, think about the hands it has passed through, the markets it might have frequented, and the tumultuous times it has survived. By researching and storytelling, you transform a simple collecting activity into a vivid historical adventure, making each coin a gateway to a bygone epoch.

This engagement goes beyond mere possession; it is about honoring and cherishing the narrative each piece brings. You might find yourself drawn to specific periods or themes, thus guiding your collecting journey. Perhaps the stories of maritime trade routes inspire you to focus on shipwrecked coins. Each coin then does not just represent a financial or aesthetic value; it holds a story, a piece of the puzzle of human history, engaging your mind and heart.

Continuous Learning: A Path to Staying Informed

The second pillar to staying passionate and informed is continuous, focused learning. The field of numismatics is ever-evolving with new findings, market fluctuations, and technological advancements in coin preservation and authentication. Subscribing to reputable numismatic magazines, attending seminars, and participating in online forums can keep you updated and deeply engaged with the community.

Furthermore, setting aside time each week to read the latest articles or watch webinars helps integrate learning into your routine, ensuring that your knowledge base continuously expands. This habitual learning not only fuels your expertise but also enriches your interactions with other collectors and professionals in the field, making every conversation a learning opportunity.

The Role of Community Engagement

Networking with fellow numismatists is another invigorating aspect that can sustain your passion. Coin clubs and online communities offer platforms to share experiences, trade coins, and discuss nuances of the hobby. Through these interactions, you gain insights into different perspectives and practices, stimulating your own thinking and enthusiasm.

Participating in community events, whether virtual or in person, can also introduce you to new facets of the hobby you might not have considered before, such as coin photography or numismatic literature. Each new skill or information adds a layer of depth to your hobby, making it an ever-expanding field of interest.

Strategic Collecting: Keeping the Fire Alive

Staying passionate also means continuously challenging yourself with new goals and projects. Perhaps you decide to complete a series of coins issued during the reign of each British monarch or track down elusive mint marks from a specific country. Setting such specific targets can reinvigorate your interest and motivation, pushing you to explore new avenues and resources.

Moreover, attending coin auctions and traveling to far-flung places in pursuit of unique coins can turn your collecting into an exhilarating adventure. Each expedition brings new stories and experiences, fueling the narrative of your personal collection.

Balancing Passion with Practicality

While passion is the driving force behind coin collecting, balancing it with a practical approach ensures a sustainable and rewarding hobby. This means setting realistic expectations and budgets, and knowing when to step back to reflect on your collection's direction and your personal goals. It also involves taking care of the logistical aspects of collecting—insurance, proper documentation, and secure storage—which, while less glamorous, are essential to protecting your investments and peace of mind.

Reflection and Rejuvenation

Finally, maintaining a passion for collecting coins is about allowing yourself the time to reflect on your progress and to celebrate your achievements. Take moments to appreciate your collection, not just for its monetary or historical value but as a reflection of your dedication and love for numismatics. Such moments of reflection can reignite your passion and remind you why you started collecting in the first place.

FUTURE TRENDS IN COIN COLLECTING

In recent years, the digital realm has begun to imprint itself significantly on coin collecting. Online auctions and virtual trade shows have become increasingly commonplace, breaking down geographical barriers and expanding collectors' access to rare and sought-after pieces worldwide. This trend is likely to continue, with more sophisticated platforms emerging to facilitate trade, learning, and community-building among collectors.

Moreover, the popularity of digital currencies and blockchain technology introduces fascinating possibilities for numismatics. Consider the concept of "NFTs" (non-fungible tokens) — digital assets verifiable through blockchain technology that has revolutionized art collecting. It's not far-fetched to imagine a future where rare digital coins or tokens become coveted collectibles, embodying value both as historical artifacts and as modern digital assets.

Environmental and Ethical Collecting

As environmental awareness and sustainability become paramount in consumers' minds, these values will inevitably impact numismatics. Collectors might begin prioritizing coins made from sustainably sourced or recycled materials, or those produced through environmentally friendly processes. The ethical dimensions of collecting, particularly concerning the provenance and acquisition of ancient coins, will also become increasingly prominent. Collectors will need to be more diligent in ensuring that their acquisitions are ethically sourced, respecting cultural heritage and legal statutes.

Shifts in Collecting Demographics

The demographic profile of coin collectors is also evolving. As younger generations become more involved, they bring new perspectives and preferences that shape the hobby. These collectors are likely to be more attuned to the stories behind coins, interested not only in their monetary or historical value but also in their cultural significance. This shift could lead to a broader, more inclusive appreciation of world coinage and medallions, reflecting a globalized perspective.

Additionally, technology-savvy younger collectors will drive demand for augmented reality apps and online tools that enhance the educational aspects of collecting, such as virtual tours of renowned collections and interactive databases that tell the history behind each coin.

The Influence of Global Economics

The global economic landscape invariably affects coin collecting. Fluctuations in currency values, changes in trade policies, and economic downturns can alter the market significantly, influencing both the availability and value of certain coins. Collectors will need to stay informed about global economic trends and adapt their collecting and investment strategies accordingly. Moreover, as more countries experience economic growth and development, new markets for coin collecting

will emerge. Collectors and investors might find burgeoning opportunities in regions previously overlooked, necessitating a more nuanced understanding of different cultural histories and their numismatic expressions.

Education and Accessibility

The future of coin collecting will likely see an increased emphasis on education and accessibility. Museums, universities, and even private collectors are beginning to recognize the value of making their collections more accessible to the public. This trend towards democratization will help in cultivating a broader interest in numismatics, engaging community members who might not have previously had the opportunity to explore coin collecting.

Educational initiatives, from online courses to public exhibitions and lectures, will play a critical role in this respect, sparking curiosity and providing the foundational knowledge necessary for new generations of collectors to enter the hobby.

Personalization and Specialization

Finally, the trend toward personalization and specialization in collections is expected to deepen. Technology will enable collectors to curate their collections with greater precision, using data analytics to track down rare pieces that fit specific niche interests. As a result, we may see a rise in highly specialized collections that reflect individual collectors and their unique passions, whether thematic, historical, or geographical.

Predicting the future is inherent with uncertainties, but by observing emerging trends and adapting to new technologies and societal shifts, coin collectors can anticipate changes and position themselves advantageously. Embracing these future trends with an open mind and a proactive attitude will ensure that the hobby of coin collecting remains vibrant and fulfilling for generations to come. Engaging with these new advancements and ideas will not only add depth to our current collections but will also open doors to enriching experiences and knowledge, reaffirming our passion for this timeless pursuit.

www.ingramcontent.com/pod-product-compliance
Lightning Source LLC
Chambersburg PA
CBHW062314220526
45479CB00004B/1165